IMAGES OF AMERICA

OLD YORK BEACH

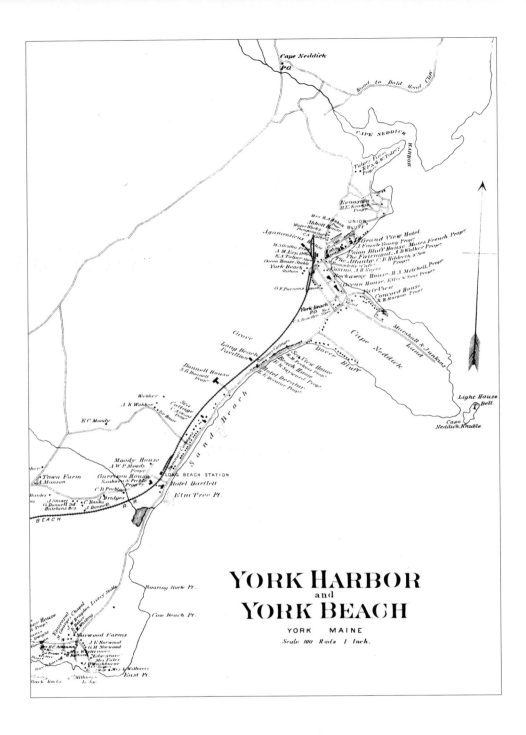

YORK HARBOR
and
YORK BEACH

YORK MAINE

Scale 100 Rods 1 Inch.

IMAGES OF AMERICA

OLD YORK BEACH

JOHN D. BARDWELL

ARCADIA

Dedicated to the memory of Russell Freeman,
a kind and gentle man. He was my friend.

Frontispiece: Map of York Harbor and York Beach from Stuart's
Atlas of Maine, published in 1890.

Copyright @ 1994 by John D. Bardwell
ISBN 0-7385-1262-1

First published 1994
Re-issued 2003

Published by Arcadia Publishing
an imprint of Tempus Publishing Inc.
Charleston SC, Chicago, Portsmouth NH,
San Francisco

Printed in Great Britain

Library of Congress Catalog Card Number: 2003106984

For all general information contact Arcadia Publishing at:
Telephone 843-853-2070
Fax 843-853-0044
E-mail sales@arcadiapublishing.com

For customer service and orders:
Toll-Free 1-888-313-2665

Visit us on the internet at http://www.arcadiapublishing.com

Contents

SOUVENIR WALTZ SONG

TAKE ME TO THE

GAY WHITE WAY

Arranged by

Marion Payne

Words and Music by

Edw. W. Young

Featured in the BALL ROOM by

Cartwright's Orchestra and Quartette

PRICE 25 CENTS

PUBLISHED BY

The Gay White Way Amusement Co.

WILLIAMSON & PATCH, M'f'rs.

York Beach, - - Me.

Introduction

The first summer boarders came to tree-shaded York Village in 1857, when John and Samuel Goddard found rest and relaxation in the home of Mr. & Mrs. Stephen Grant. More and more people had reached the station in society where they could lay aside their responsibilities during the summer months. Requests for accommodations caused the Moodys, the Youngs, the Goodwins and the Norwoods to open their homes to the visitors. George Goodwin owned a field adjoining Long Beach which he sold to Henry C. Lord of Cincinnati in 1866. Lord built a property known as the "Lord House", the first of many summer homes to be built along the wind-row of stones that later became Long Beach Avenue. In 1880 the house became part of a structure known as the Hotel Bartlett, one of the first of many summer hotels to be opened in the area. A second cottage, known as the Kittery House, was built in 1867 at the eastern end of Long Sands Beach near the entrance to Nubble Road. Built for one hundred and thirty dollars, it was owned by ten people who used it as a base for fishing and social activities.

Maffit W. Bowden opened the very first York Beach summer hotel in 1869. The Sea Cottage, later called the Hotel Mitchell and still later the Anchorage, was opened to the public in 1871. Other early hotels were the Donnell House and the Thompson House, which later became Young's Hotel. They were followed by the Rockaway, the Ocean House, Union Bluff, Agamenticus, the Hastings Lyman, the Hiawatha, the Wahnita, the Kearsarge, the Bald Head Cliff House and the Passaconaway Inn. In addition to this development, over five hundred and fifty summer dwellings were built during the fifty years after 1865.

By the 1890s transportation had evolved from stagecoach and buckboard to steam railroad and electric car. Summer guests bathed in the ocean, hiked in the mountains, picnicked on the river banks, took buckboard rides to Chase's Pond, played tennis and golf, and danced at the hotels and dance halls. Baseball teams made up of hotel employees carried on a lively competition that attracted many spectators. Itinerant performers entertained hotel guests, and livery stables offered carriages and saddle horses

for hire. Employment opportunities increased and young men and women of York families found summer employment as waitresses and maids in hotels, clerks in stores, servants in summer homes, as delivery boys, coachmen and hotel porters. The arrival of the automobile in the early years of the twentieth century made country places more accessible and made a major contribution to a "back to nature" movement. Auto touring created a need for picnic areas, service stations, cabins, campgrounds, and roadside lunch counters. Summer vacations became shorter, day trippers became more common, and summer resorts created amusement centers to attract vacationers.

The photographs, postcards, and ephemera in this publication were arranged to reflect this intriguing formative period in the history of a Maine summer resort. It is my hope that this will be a handbook of York Beach history for those who want to know what it was like in "the old days".

John D. Bardwell

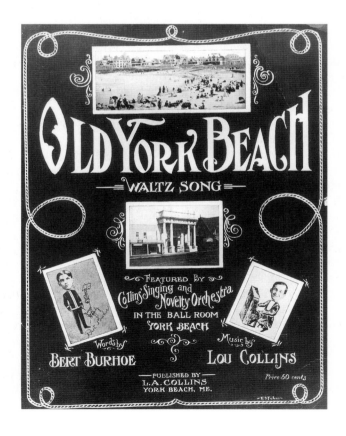

one

Where did they stay?

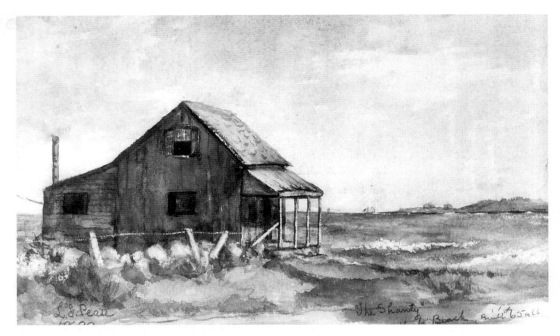

The "Shanty" or Kittery House, c. 1867. It was located on the eastern end of Long Sands Beach near the entrance to Nubble Road. From a painting by L. F. Pease in 1900.

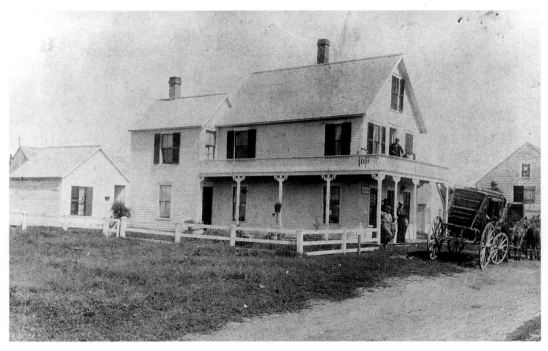

The Bowden House in 1881. The stagecoach is boarding passengers at this early York Beach boarding house.

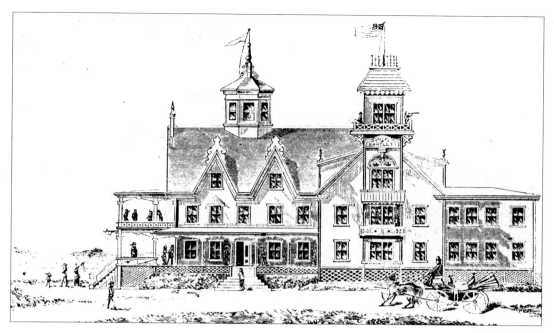

The Hotel Bartlett, originally part of the Lord House, was open for business in 1880. This postcard advertised the hotel as having every facility for boating, fishing, swimming, and pleasure riding. The proprietor, H. E. Evans, proudly announced that "The hotel has been rebuilt and refitted, and no pains will be spared to make it first-class in every particular." It is a rare example of a wooden building in the High Gothic Revival style.

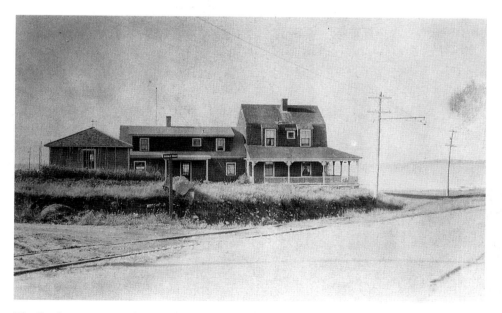

The Breakers, a cottage that was probably built on the site of the Kittery House near the entrance to Nubble Road. This is how it appeared around 1920.

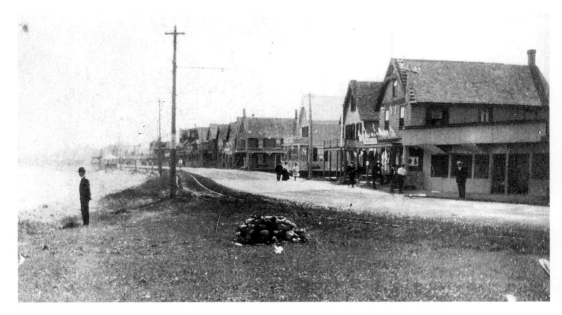

View of Long Sands Beach from The Breakers. The first cottage on the right was the Andover–Lawrence Cottage, which later became the Perkins Boarding House. The Breakers was torn down to make way for the Cutty Sark Motel.

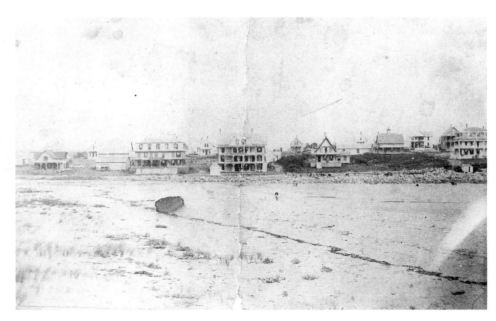

The original hotels on Union Bluff near the edge of Short Sands Beach. Left to right: The Fairmont Hotel, the Driftwood Hotel, and the Thompson House on the far right.

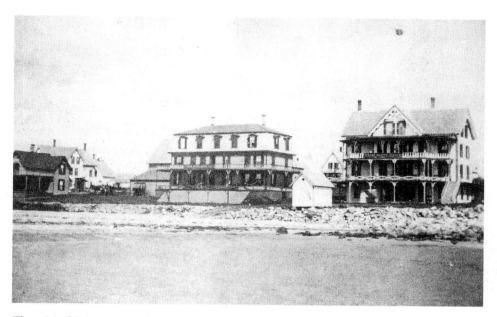

The original Fairmont Hotel is on the left. On the right is the Driftwood, which at various times in its later history was also called the Wahnita, the York Plaza, and the Union Bluff.

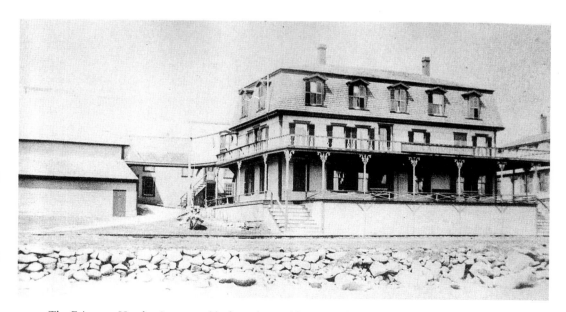

The Fairmont Hotel as it appeared before a large addition was built on the left side of the building. The original building was modest in size but its ideal location on the edge of the beach made it popular with tourists. The growth of York Beach as a summer resort led to the expansion of many of the area's hotels.

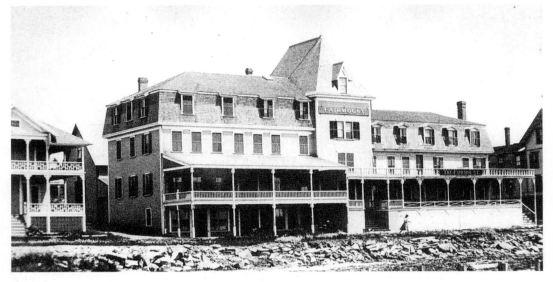

An addition to the Fairmont Hotel doubled its size and completely changed its appearance. Note that the stairway from the porch in the original building is now in the center of the expanded facility. The hotel was enlarged to hold one hundred and twenty-five guests.

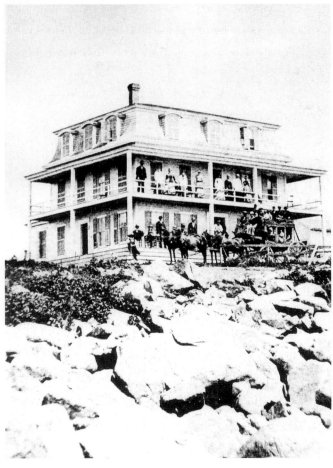

The Thompson House, managed by Henry E. Evans in the 1880s, was one of the first hotels on Union Bluff. Note the stagecoach filled to capacity. Young's Hotel was later built on this site.

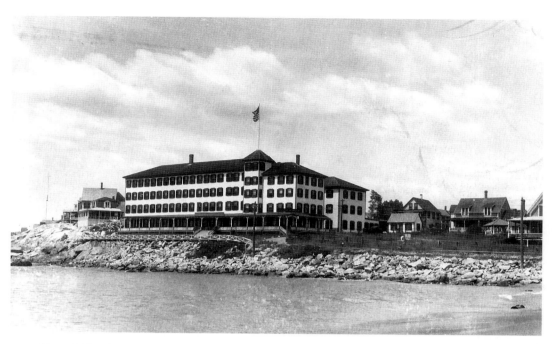

Young's Hotel, c. 1922, replaced the Thompson House on Union Bluff. It was the largest of the old hotels and could accommodate two hundred and fifty guests.

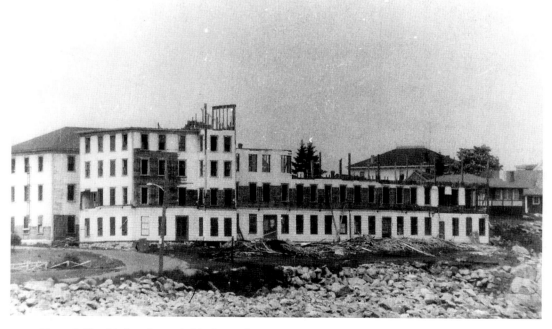

Young's Hotel being dismantled in September 1965.

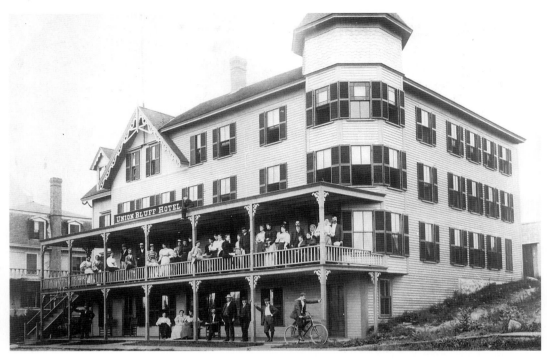

Guests fill the porches of the Union Bluff Hotel, originally the Driftwood Hotel. Here the top porch has been removed and rooms added to the rear and to the third floor. A tower has been added on the right.

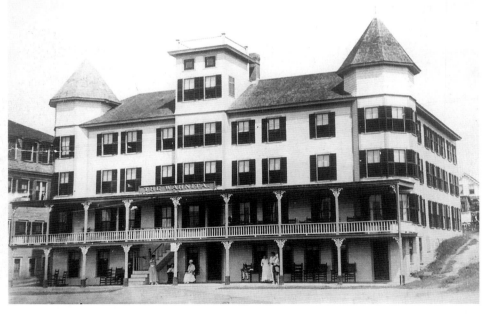

Renamed the Wahnita, the building has been expanded on the left, another tower added, and the central peaked dormer replaced with a square tower.

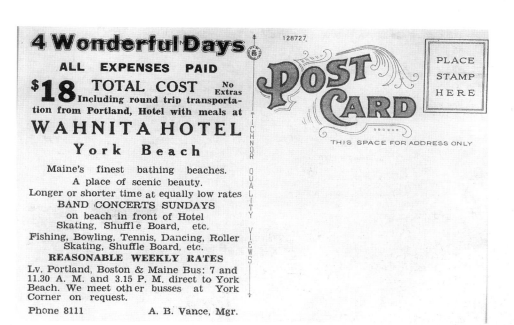

Eighteen dollars would buy a four day vacation at the Wahnita, including meals, and round-trip transportation from Portland. It was common for hotel managers to send such postcards to prospective vacationers, especially former customers.

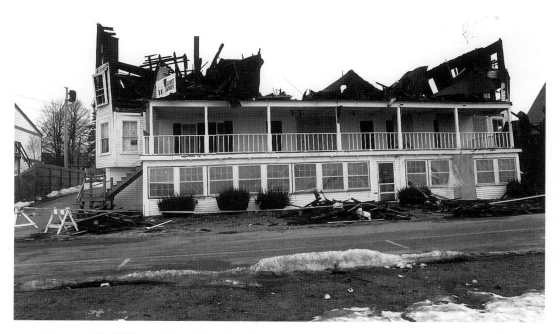

Renamed the Driftwood, the old hotel was burned by an arsonist in 1987. It was rebuilt to resemble the original hotel and was again named the Union Bluff.

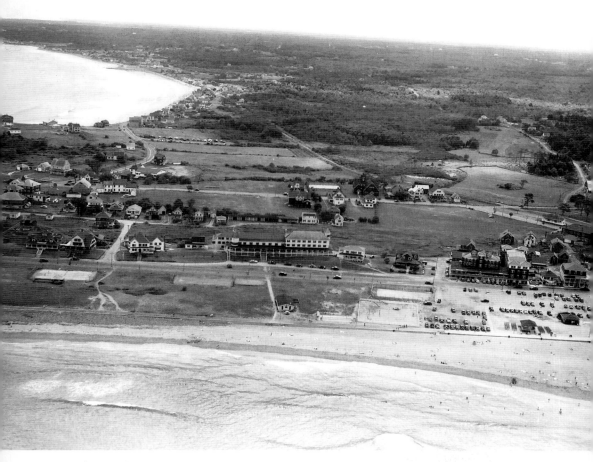

An aerial view of York Beach showing the Ocean House in the center of the photograph and Ellis Park, around 1944. The parking lots were still relatively empty at this time and there were no parking meters. The Ellis Park area had tennis courts and bath houses, and the Ocean House, like most summer hotels, had its own orchestra or band, livery stables, bath-houses, and card rooms. These were described in brochures that also praised the clean air, pure water, cool nights, and active social schedule. Many of the first tourists were invalids who came to the seacoast to seek a cure in the fresh air. They also felt that fresh farm products would help them regain their health. Rocking on the porch of a cottage or a summer hotel probably cured many of the stress-related ailments.

Opposite below: The Ocean House, located on a ridge overlooking Short Sands Beach, was owned by the Ellis family for many years. Their gift to the people of York Beach insures that the public will always have access to the beach front, which is maintained without spending tax dollars. In 1983, the trustees voted to officially name the property Ellis Park.

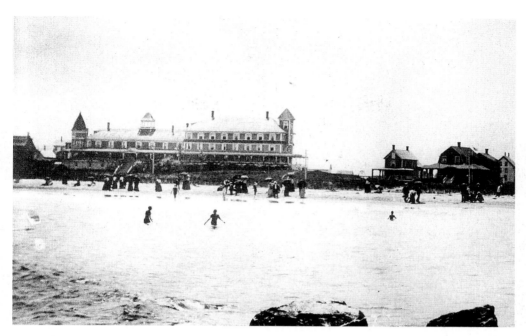

Ellis Park was created in 1887, when Ellen B. Ellis, for the Ellis family, designated the land in front of the Ocean House for use as a public park. The property was transferred to the York Beach Village Corporation in 1917. The trustees were permitted to install parking meters if the fees were used for the upkeep and improvement of the park.

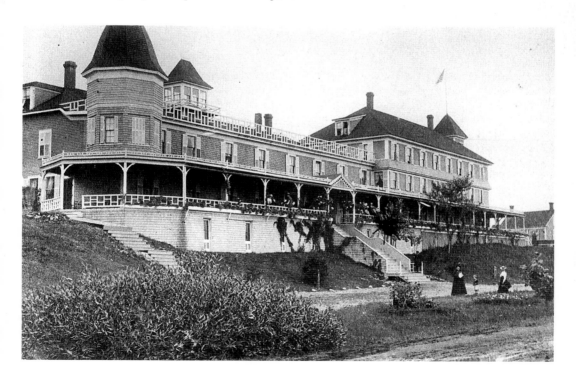

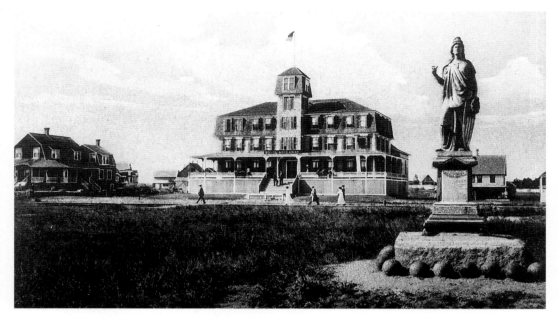

The Hotel Rockaway was located near the Ocean House facing Short Sands Beach. The statue was a monument to the soldiers and sailors who served in several wars. The statue was destroyed but the base was saved and relocated in Ellis Park.

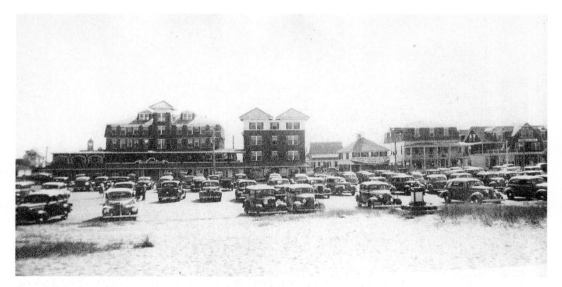

The Lafayette Inn was created when the Hotel Rockaway was enlarged and remodeled. In later years, it was known as the Breakers Hotel. The section that was the Hotel Rockaway can be seen at left.

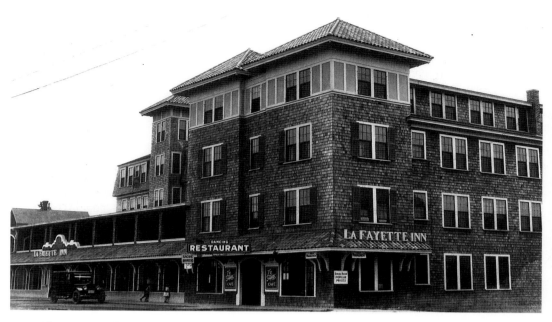

The restaurant featured 'shore dinners' for $1.25, and a café where a dance band played nightly. The four story building had one hundred and twenty rooms.

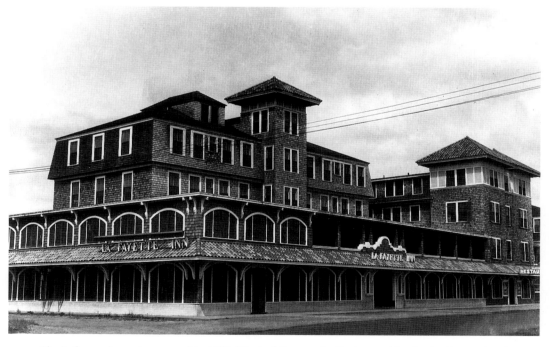

The Lafayette Inn as it appeared in 1923. The building was badly damaged by fire in 1958 and replaced by the Sands Motel.

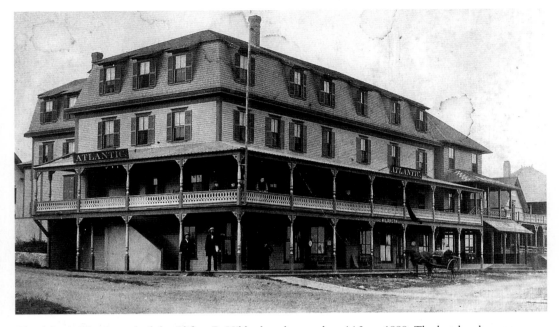

The Atlantic House was built by Clifton B. Hildreth and opened on 14 June 1888. The hotel and annex had fifty rooms altogether. The dining room seated two hundred and fifteen people and the first three levels were piped with running water. Drainage and sanitary facilities were excellent for the time, with a sewer extension that drained directly into the ocean.

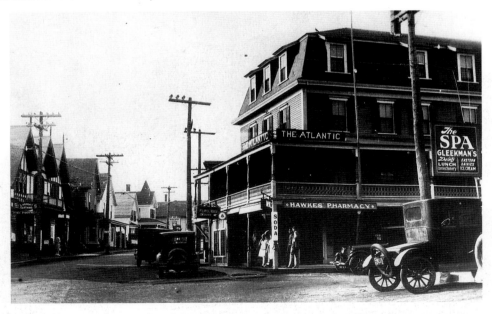

The Atlantic House had rooms with ash bedroom sets, woven wire springs, hair mattresses and blankets. The rooms had tapestry carpeting, and the parlor was furnished in hair cloth with a new upright piano. Located on the corner of Atlantic Avenue and Cape Neddick Street, it was sold at auction in 1894 for nine thousand dollars.

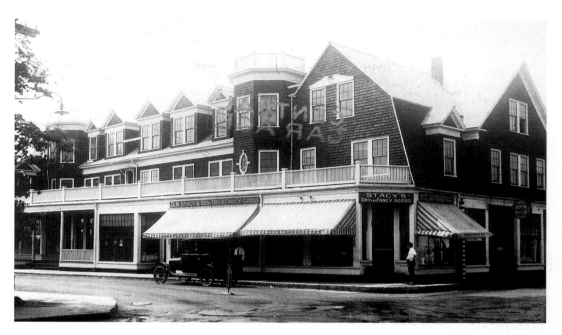

The Kearsarge Hotel, later called the York Beach Hotel, and now Shelton's. Some of the original sleeping chambers still exist on the third floor. They are very small, with hardly enough room for a bed and a wash-stand. At the end of a long hall is a water closet with a small sink and a flush toilet which served all the rooms on that hall.

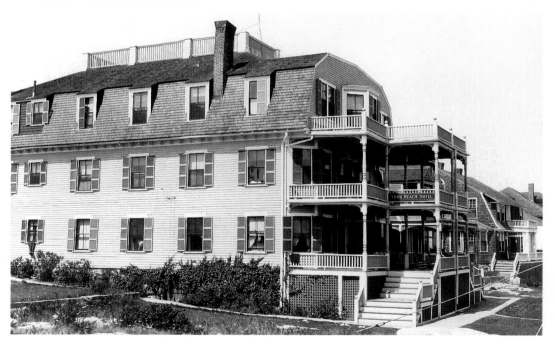

The Hastings-Lyman Hotel on Union Bluff was also known as the York Beach Hotel, as the sign in the picture indicates.

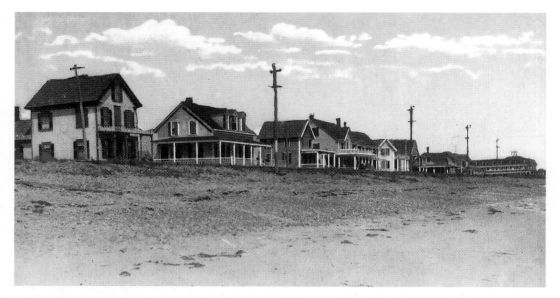

Cottages on the west end of Long Sands Beach are shown on this postcard with the Hotel Mitchell on the far right of the picture.

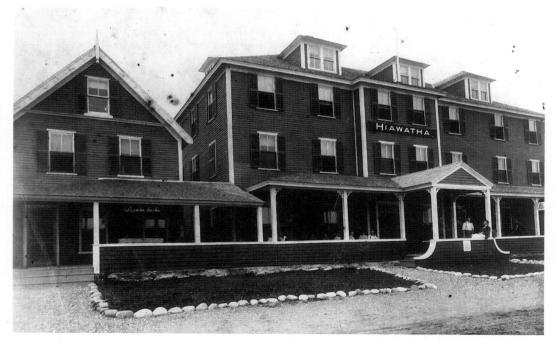

The Hiawatha Hotel was one of the first to open on Long Sands Beach. Located near the site of the present Nevada Motel, it was also near the Oceanside railroad station and trolley cars passed directly in front. Many cottage residents took most of their meals at the Hiawatha where a pianist and a violinist played during dinner. The hotel was torn down during the winter of 1936-37.

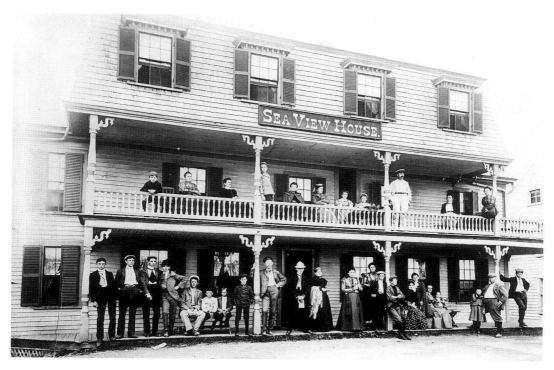

The Sea View House was another early hotel on Long Sands Beach. Guests and employees filled the porches for this picture to be taken. The busy dining room provided work opportunities for many young women who served as waitresses and lived in a building behind the hotel.

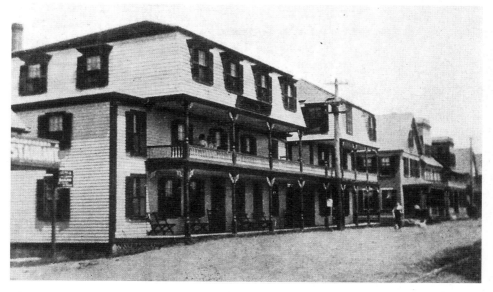

The Sea View House was expanded when trolley cars began to carry large numbers of summer travelers to the beaches at York. One guest fondly recalled toasting marshmallows on the beach, picking blueberries behind the hotel, and eating steamed clams on Saturday night.

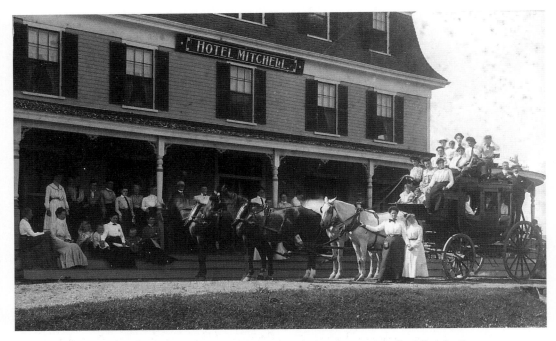

A stagecoach at the Hotel Mitchell on Long Sands Beach. The hotel was originally called the Sea Cottage when it was opened in 1871. Regular guests, who usually came for the season, often had the same room and dining table each year. Each table was set with personal prescriptions, vitamins and miscellaneous pills.

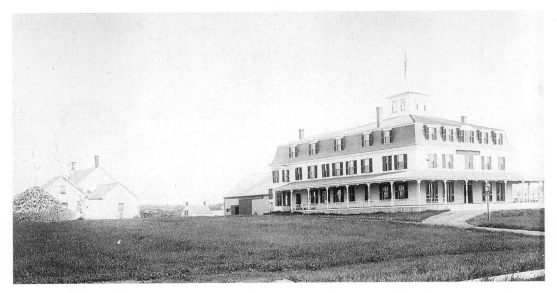

It became the Anchorage Hotel when Ed and Ida Mitchell sold the entire complex to Seares Duarte. The deal apparently included lifetime guest privileges for Ada, including her own table in the dining room.

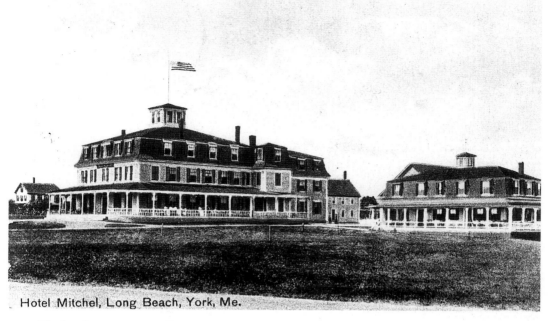

Hotel Mitchel, Long Beach, York, Me.

The hotel's name is misspelled on this postcard, which shows the hotel and its annex. The annex provided accommodations for transients and younger guests who liked to party.

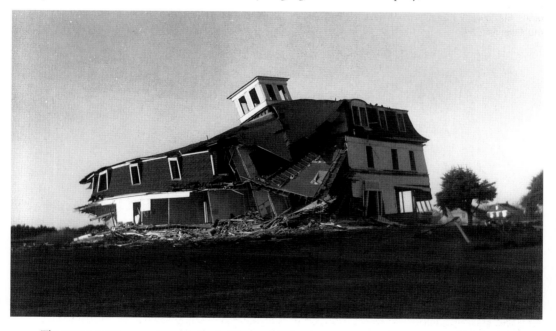

The tower room was assigned to the bell boy as his sleeping quarters, perhaps to arouse him for work at the crack of dawn. Other employees found rooms in local cottages. It was called the Anchorage Hotel when it was razed to make room for the Anchorage Motel which now occupies the site. At the time of its demise, it was probably the second oldest hotel in York.

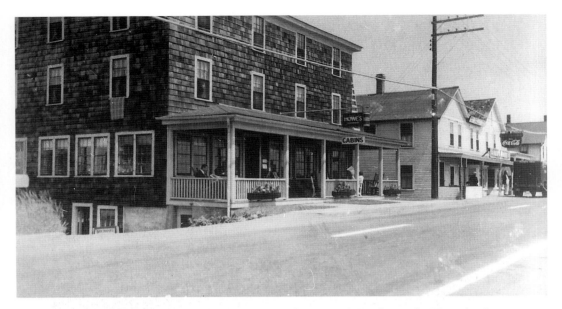

Howe's Tavern and Salls' Store were on the eastern end of Long Sands Beach near the Hiawatha. In 1910, Elmer Howe rented A.C. Farwell's store and restaurant for his two daughters, Ethel and Mildred. The two women ran the store and cooked light breakfasts for guests from the Hiawatha and the Atlantic House.

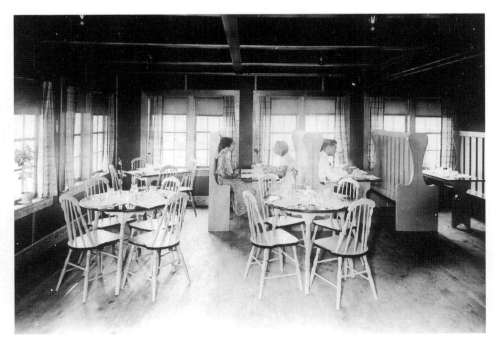

The dining room at Howe's Tavern. When Elmer Howe died, his widow provided funds to tear down the store and construct a rooming house which they called Howe's Tavern. Ethel Howe managed the business and added to the small lot by purchasing land behind the tavern.

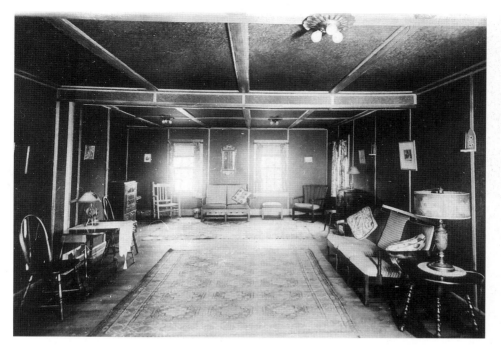

The living room at Howe's Tavern. Joseph Bobroff helped run the tavern. He and Ethel Howe were married in the 1940s and they ran the business together for many years.

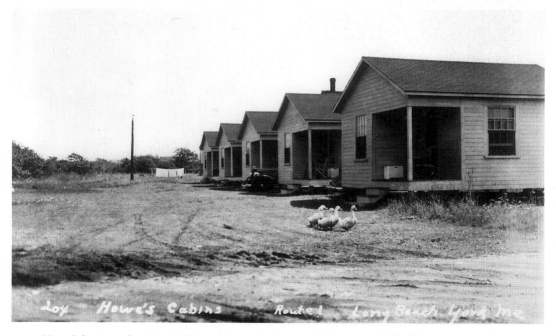

Howe's business also included five cabins and a cottage which were available for summer rental.

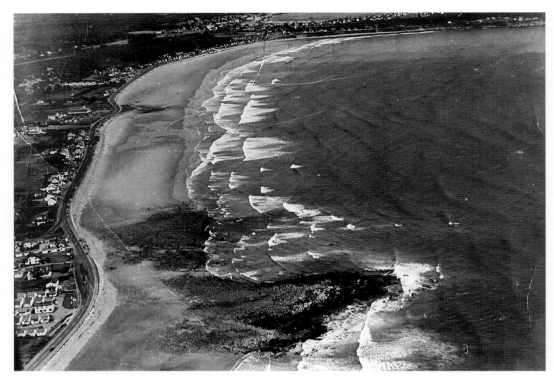

Aerial view of Longsands Beach from Elm Tree Point to Cape Neck peninsula.

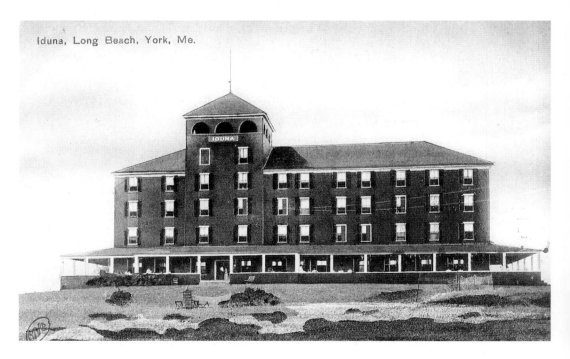

Iduna, Long Beach, York, Me.

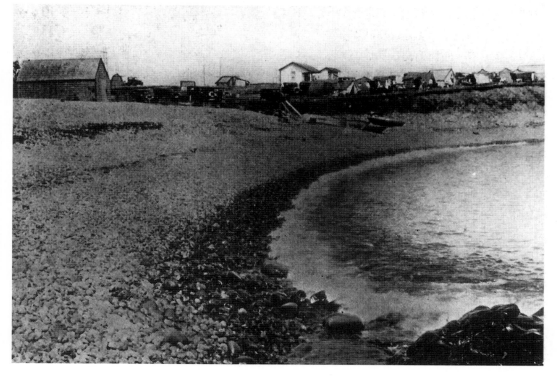

Libby's Oceanside campground with Lobster Cove in the foreground. The boats and fishing shacks belong to the local fishermen. Lobster Cove was used by fishermen who eventually moved to the shelter of York Harbor when boats became motorized and could overcome the strong currents at the harbor entrance. Libby's Oceanside Campgrounds were on the easterly outskirts of York Harbor and expansion of the popular campgrounds threatened the property values in York Harbor. The York Harbor Village Corporation enacted its own zoning laws to restrict stores, shops, hot-dog stands and public garages to certain areas. It required building permits and banned billboards. The corporation enjoined Libby from maintaining a campground for public gain within the restricted area. The Maine Supreme Court held that the ordinances were constitutional and thus established the right of municipalities to enact and enforce reasonable zoning ordinances.

Opposite below: The Iduna Hotel. Opened in 1897, it was built in ninety days on the site of the Donnell House which was destroyed by fire. Later named the Twin Lights Hotel, it also burned on 23 June 1937.

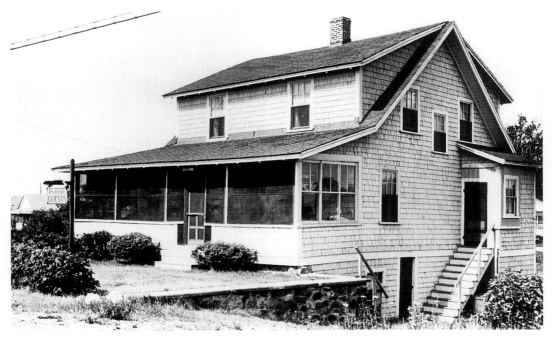

The Eastwind, at the corner of Long Sands Road and Long Beach Avenue, was probably built by Mildred Jenkins who operated it as a rooming house. She sold it to Susan and George Ackerman in 1947, but the numbers are still on the doors from the days when it was used as a rooming house.

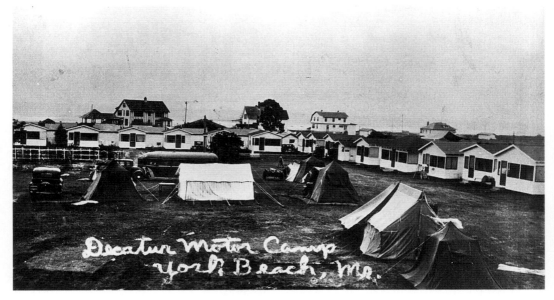

Decatur's Motor Campground and cabins near the intersection of Long Sands Road and Long Beach Avenue. A neat row of white cabins lined the edge of the camping area with just enough space between cabins to park an automobile. Shown here are tents of different shapes and sizes, and a trailer in the center of the campground.

The Toby House on Long Sands Beach offered a coffee shop, soda fountain, dining room, rooms and cottages.

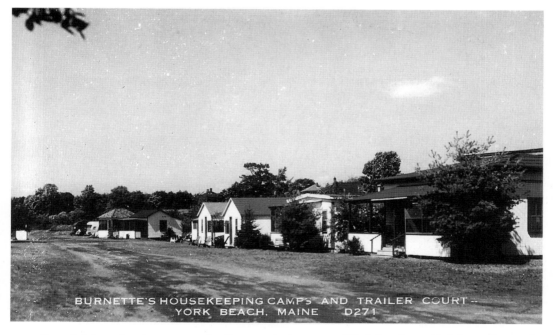

Burnette's housekeeping camps and trailer court in the center of York Beach provided the usual mix of cabins, campsites, and trailer spaces.

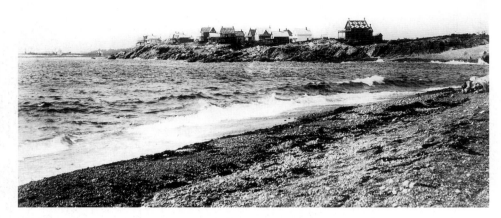

Cottages off Freeman Street lining Union Bluff. This photograph was taken between 1881 and 1885. The cottage on the right, with geometric patterns on the roof, was sold to Reverend Sperry by Hazen Ellis. Sperry's son, Willard, described the cottage in his book, *Summer Yesterdays in Maine*. He wrote, "When we first got it, the cottage was finished in rough pine boards. Upstairs, there was no ceiling to the bedrooms, only rafters and the sloping roof overhead. The pine partitions went up high enough to insure privacy for the purposes of dressing and undressing, but there they stopped." Sperry described his little world as, "Bounded on the south by crystallized popcorn, molasses kisses, and a gorgeous sand beach; bounded on the east by rocks and pools and starfish and toy boats; bounded on the west by huckleberry bushes and spruce gum oozing out of trees; bounded on the north by the harbor, the river, the bridge cunners and flounders; it was a good world in which lots of different things could be done and found."

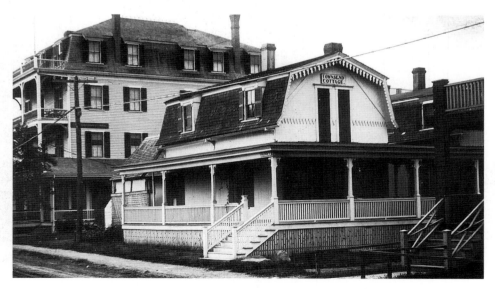

Townsend Cottage. One of the cottages reflecting the architecture of the early 1900s.

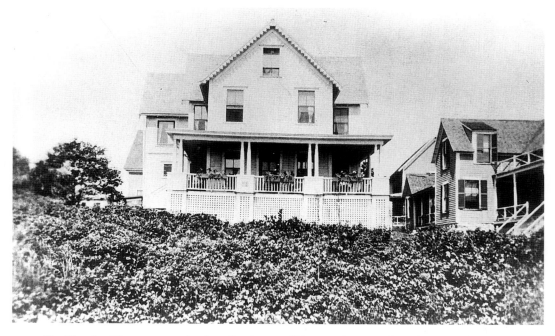

The Thrasher House was another boarding house off Freeman Street, and was located at the intersection of Belmont Avenue.

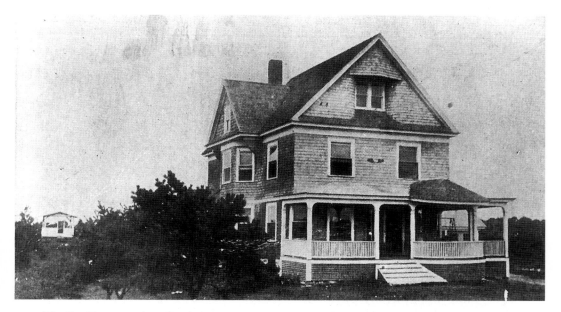

The Sea Pines was a boarding house on Beacon Street near the Iduna Hotel. It was operated as a guest house by Mrs. Mary Davis until 1944 when it was purchased by Mr. and Mrs. Walter Dews for use as a private home. It burned in 1947.

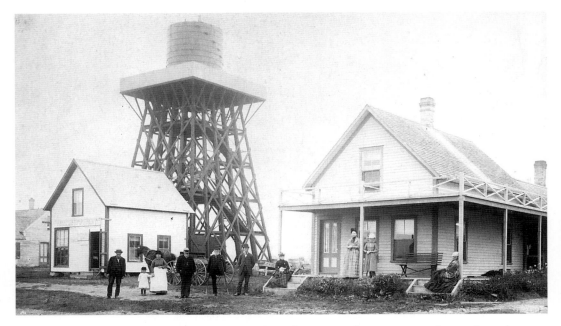

Colby's dry goods store and water tower on Hildreth's Hill, c. 1900. The store was two houses down the hill from Chase's Garage opposite the entrance to Freeman Street. The building has had several additions and the porch has been removed , but it is still in its original location.

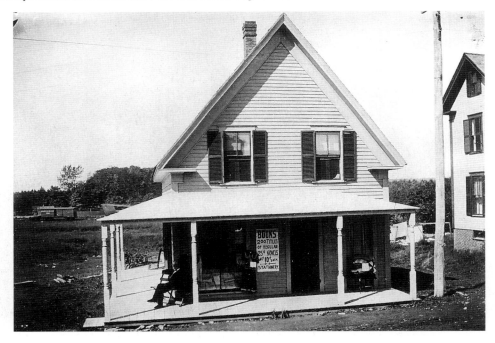

"First Store – Now a Cottage" was written on this cyanotype of Colby's store. The sign advertises two hundred book titles available for ten cents each, and stationery was available for vacationers who felt the need to write home.

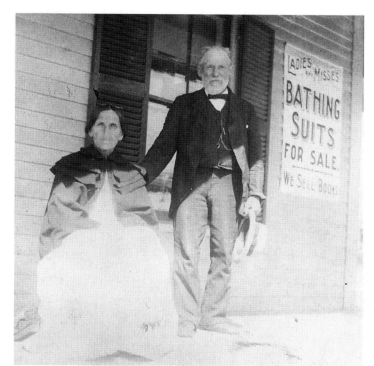

George Colby and his wife on the porch of their store. Mr. and Mrs. Colby were among the first shopkeepers in York Beach. Note the sign advertising ladies and misses bathing suits for sale. They also sold penny candy.

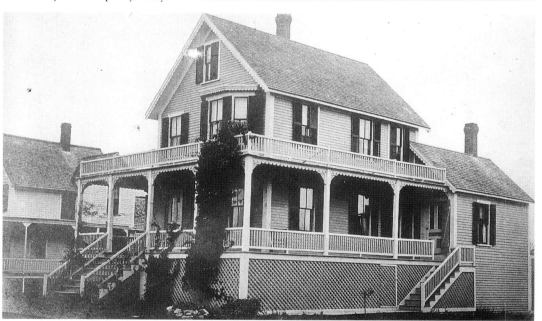

Large cottage on Freeman Street. It was typical of the type that took boarders including young people who were employed by summer business establishments.

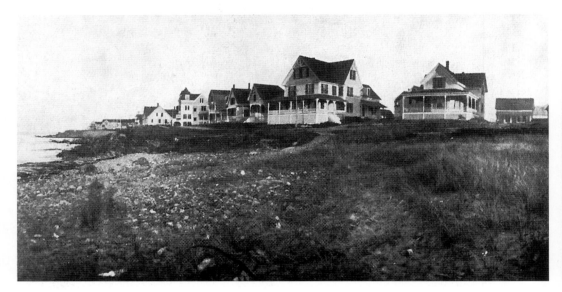

Concordville. The bluff on the western end of Short Sands Beach was the favorite vacation home for many people from Concord, New Hampshire.

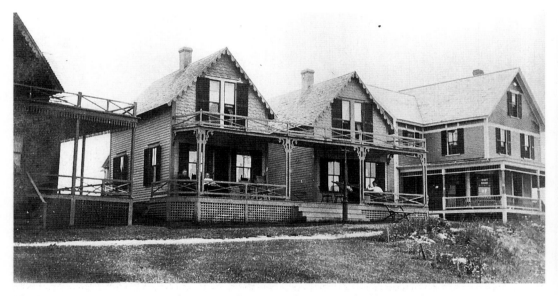

The Twin or Bourne Cottages as they appeared in 1907. These unique buildings can be seen in the center of the postcard of Concordville above.

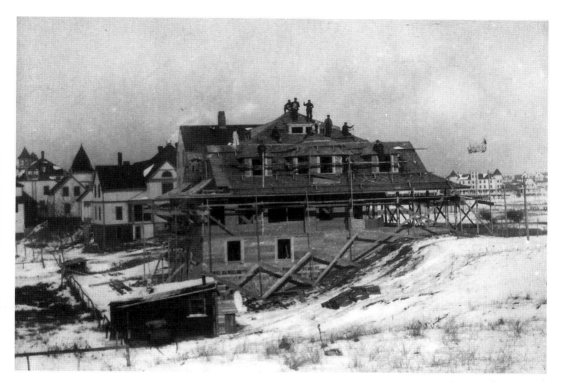

The R.G. Sullivan House was one of the large residences that were built for those who could afford expensive summer "cottages" overlooking the ocean. This was located near the Ocean House at Short Sands Beach.

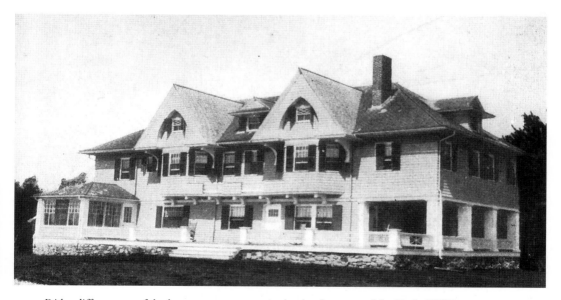

Ridgecliff was one of the large summer estates in the development of the York Cliffs Improvement Company. Cragmere, Pinehurst, Greystone, and Rockhaven were also located in this area.

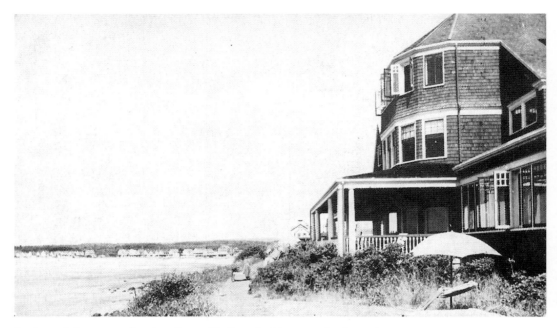

Richmond Court was a hotel on Dover Bluff overlooking Long Sands Beach.

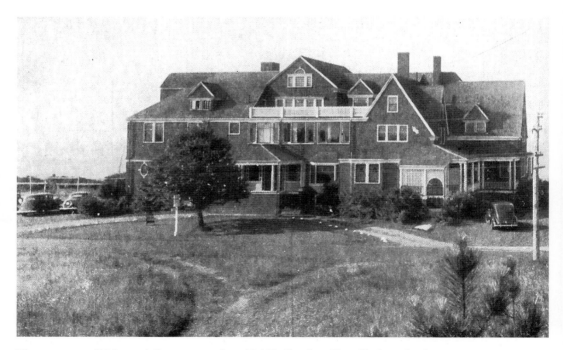

The entrance to Richmond Court as seen from Nubble Road on Cape Neck peninsula.

The large porch at Richmond Court where guests could relax and watch the ocean breaking on the rocks.

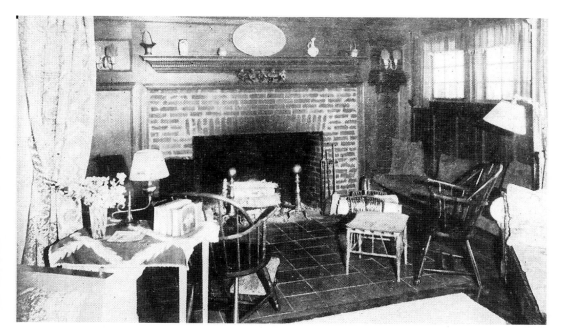

A fireplace provided the perfect atmosphere for vacationers who came to escape the tensions of the work environment.

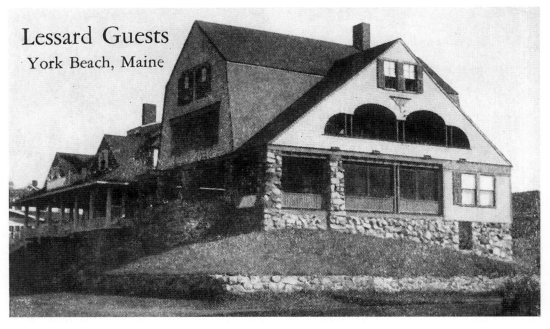

Lessard's guest house was on the ridge adjacent to the Ocean House overlooking Short Sands Beach. This was an advertising postcard that was made available to guests who wanted to send "wish you were here" messages.

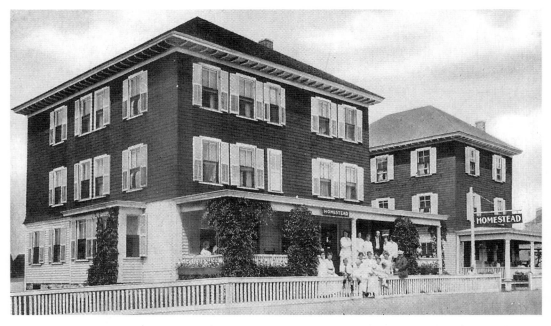

The Homestead was another large guest house on the bend near the entrance to York Beach. It was a short walk to Short Sands Beach. The employees have gathered at the front gate for this photograph.

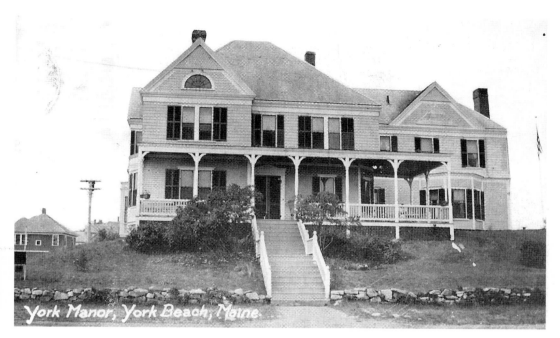

York Manor was also on the ridge near the Ocean House. The postcard read, "We are up here for a few days. This is directly opposite the beach called Short Sands. Hope you are fine. Love, Mildred." Postcards of vacation sites were extremely popular and a window was sometimes marked with an "X" to indicate exactly where the writer was lodged.

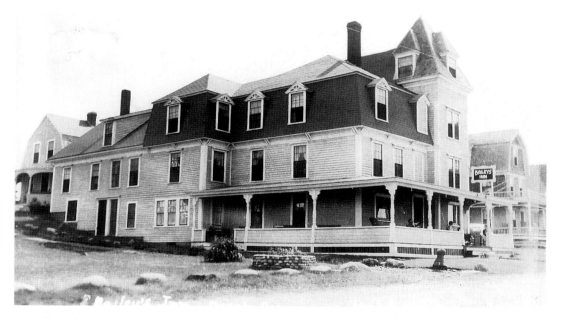

Bailey's Inn on Ocean Avenue. An employee wrote, "Dear Auntie, This is the Inn. We are having a nice time. The work is easy so far. Hope you can come up. Love, Carolyn." Many young people left home to summer at the beach and paid their expenses by working in the hotels and boarding houses.

The Old York Beach Waltz Song was written in 1911 by Bert Burhoe and Lou Collins. Dance hall regulars knew the words by heart and soon learned what it meant to sing, "A trip to the Nubble is well worth your trouble, so take your girl over today." Collins' Singing and Novelty Orchestra featured "Old York Beach" at the Gay White Way Ballroom, where it was played on a regular basis.

4

long for the clime of the win - ter time with all its ice and
stroll and a talk on the old board walk with some one fond of

snow _____ Just take a run o - ver thro' Portsmouth or Dov - er the
you _____ A trip to the "Nub-ble" is well wor th your trou-ble so

wild waves are sigh-ing for you_____ To dear old York Beach for it's
take your girl o - ver to - day_____ Or sit hand in hand by the

just with-in reach and old friendships and scenes there re - new_____
shore on the sand If you lis - ten you'll hear the waves say_____

Old York Beach 3

CHORUS

Old York Beach Old York Beach Where the blue waves roll____ Where

skies are blue and cares are few and sweet-hearts love to stroll ____ You

glide to mu-sic en-trancing ____ spoon-ing mooning and dancing ____ A

hug and kiss is not a-miss at Old York Beach ____

Old York Beach 3

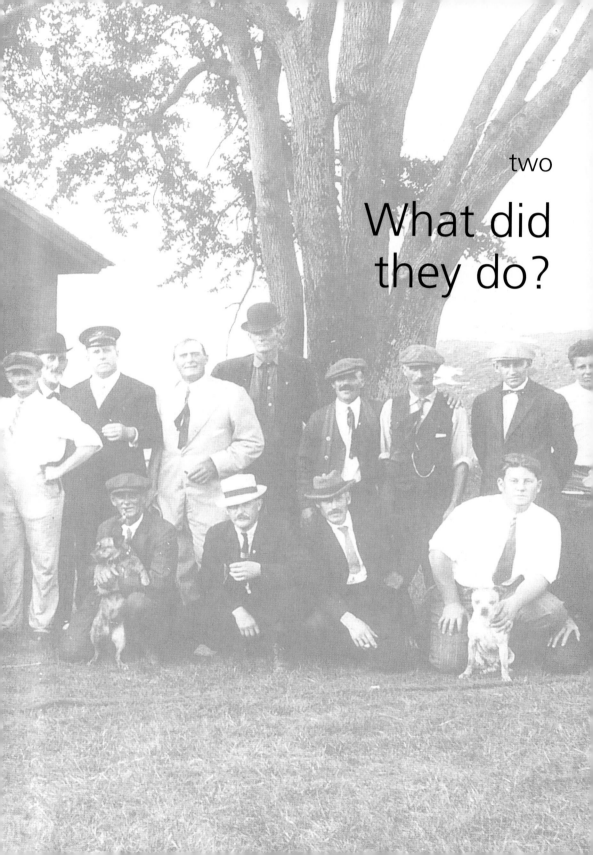

two

What did they do?

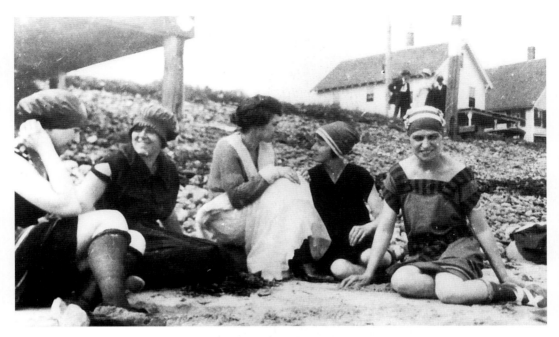

Five young women on the beach. Rita, Francis, Judy, Mrs. Dillon and Muriel model acceptable beach apparel in the 1920s. A blouse, skirt, and black stockings were fashionable. When the heavy material became water-soaked, women usually "dipped" their bodies in the water because swimming was almost impossible.

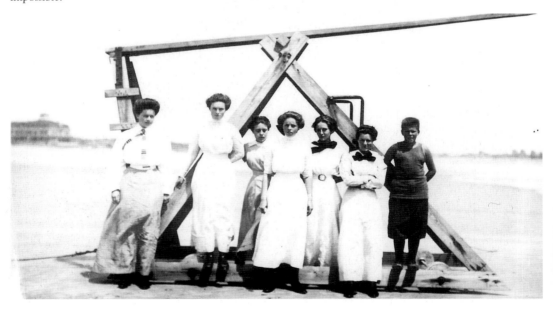

This diving platform was constructed for use at Long Beach. It had wheels that enabled the bathers to push it out beyond the breakers. A cable, attached to a winch, was used to pull the platform out of the water. A simple ladder provided access to the diving board. The women are not dressed for swimming but their clothing is appropriate for walking on the beach.

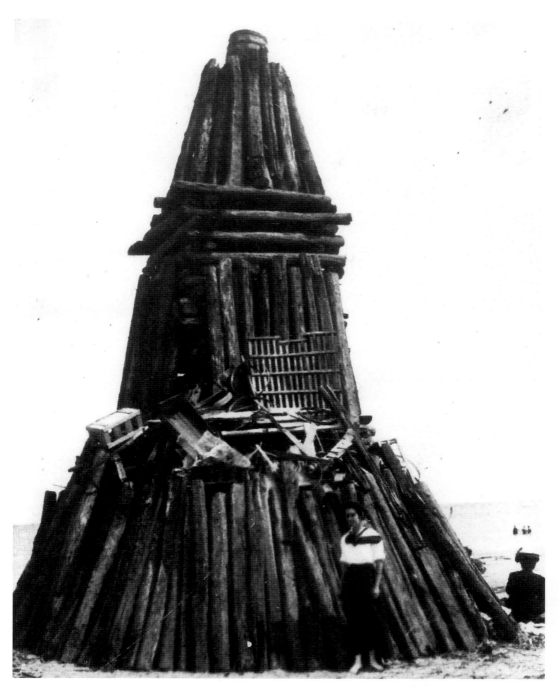

The annual July Fourth bonfire on Long Sands Beach attracted spectators from all over the area. Railroad ties were a favorite fuel because the designers could create a pyramid-shaped tower that was filled with driftwood and scraps remaining from recent cottage repairs. It was topped with a wooden barrel to symbolize that the structure met the unwritten specifications for bonfire construction. The problem was to keep the fire from starting before the designated time!

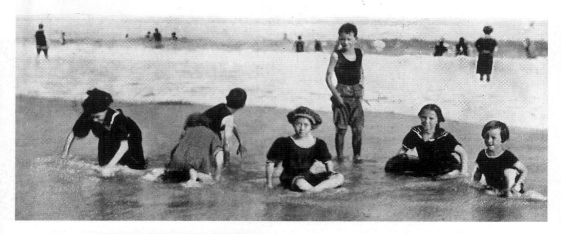

Young swimmers playing in the surf, undisturbed by the cold ocean water and the restrictive bathing costumes.

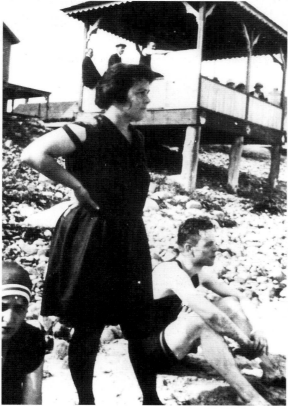

Mrs. Ralph Dillon at Long Sands Beach. Mrs. Dillon's bathing costume is appropriate for this period. The building in the background is a waiting station for the trolley cars.

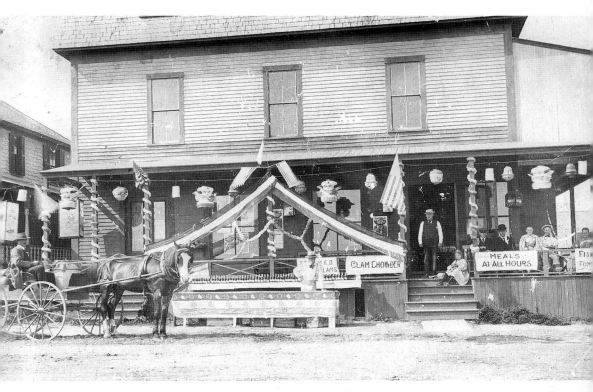

Cottages were often converted to convenience stores where you could buy everything from Japanese lanterns to fish bait.

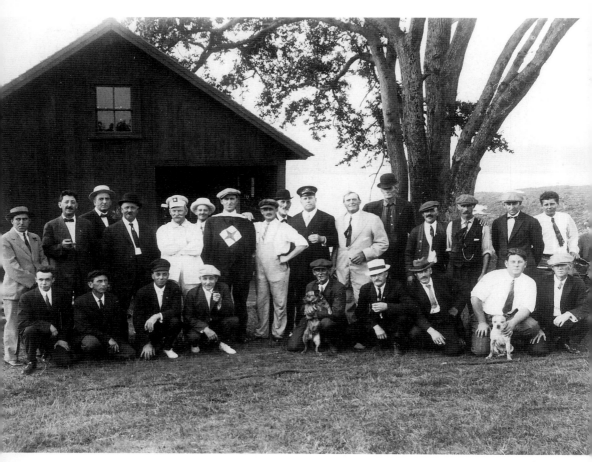

The Bay Haven Yacht Club in 1915 used an old bath house for club headquarters and the giant elm tree served as a landmark for sailors and fishermen. A boat landing and pier were built in 1911. The pier was large enough to hold tables where the members enjoyed cookouts. They also had ice cream parties and gathered there to watch the boat races. Members, standing left to right: -?-, -?-, James Anderson, Fred Frisbee, L.J. Scribner, -?-, Caleb Bowden, Malcolm Ramsdell, Richard F. Chalk, Commodore Lewis Crockett, John "Jack" Young, Treasurer George Grafton Hutchins, Charles Parsons, Will Norton, -?-, Paul Crockett, -?-. Kneeling, left to right: Ned Baker, Charlie Farwell, John Muehling, W.L. Thomas, Ralph Winn (with the dog), -?-, Frank Ellis, Laurence Seavey (with dog), and Harold Weare.

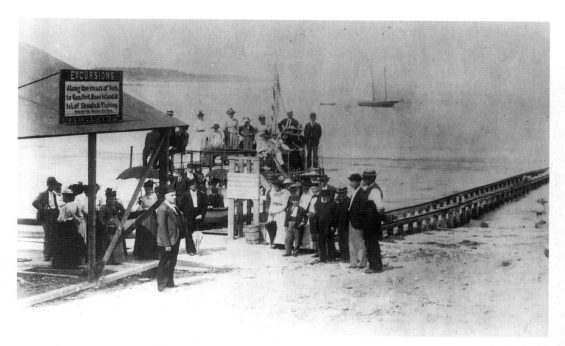

The Comet was a rail car that took passengers out into the ocean at Short Sands Beach. It was promoted by John C. Staples, c. 1889.

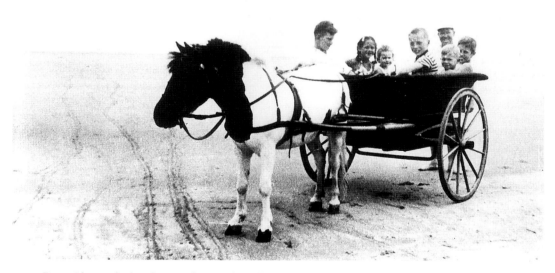

Pony rides on the beach were also popular. The wicker cart had a door in the back so passengers could climb in and out. The young people were charged ten cents for the ride. Left to right in this 1949 photograph: the driver, Lois Brinkman, Bonnie Bennett, -?-, Stuart Bennett, and David Brinkman.

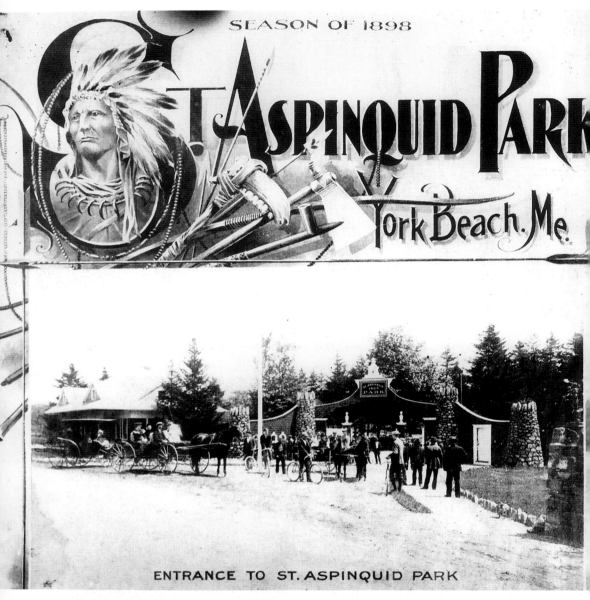

SEASON OF 1898

ST. ASPINQUID PARK

York Beach, Me.

ENTRANCE TO ST. ASPINQUID PARK

St. Aspinquid Park, owned and operated by Henry E. Evans, was built in 1898. The park was about five minutes walk from downtown York Beach. It covered an area of fourteen acres with walking paths, shady picnic areas, a café that served fish dinners, and a casino building with a large stage and dance floor. A brochure claimed that the park was located on an old Indian trail and the campsite of several tribes. A case at the entrance displayed arrowheads, spear points, stone war clubs, and other Indian artifacts.

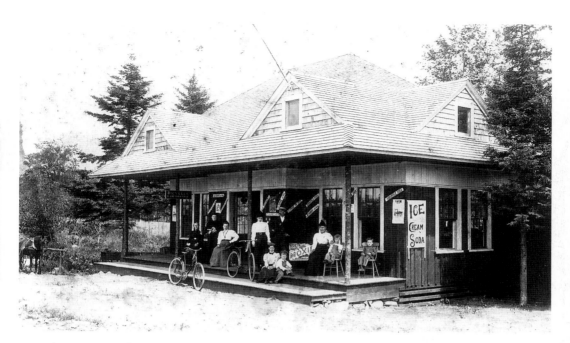

A tea room was located to the left of the park entrance. At this time it was a snack bar. Later, it became Evans' own residence. The building is still in its original location and retains many of its original architectural features.

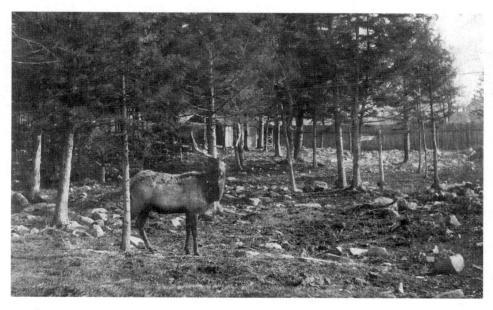

An elk was a special attraction at the park. Other animals included a collection of birds, a large bear and a monkey. Admission to the park was ten cents and admission to the casino building cost an additional fifteen cents. Children under twelve accompanied by parents were admitted free of charge. One elk was reported killed while being transported to the park. It was injured when it fell while being removed from a wagon.

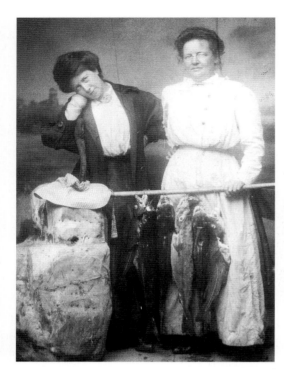

Left: Anna L. Roberts and Annie M. Cullen pose with their catch. One cod and one haddock each weighed eight pounds. The fish were caught off York Beach on 22 July 1910. Note the backdrop and the artificial rock in the photographer's studio. Apparently, the recording of fishing trophies was a regular part of the business.

Below: Sailing was a popular pastime for young people seeking solitude on a short trip along the coast.

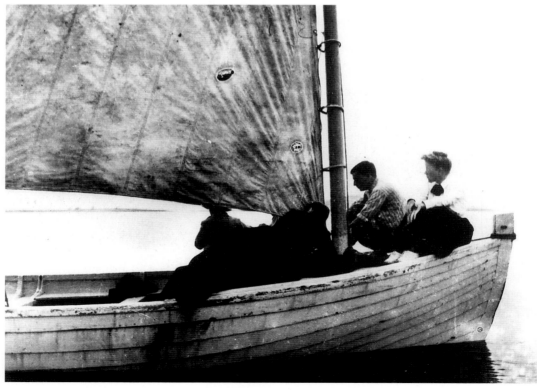

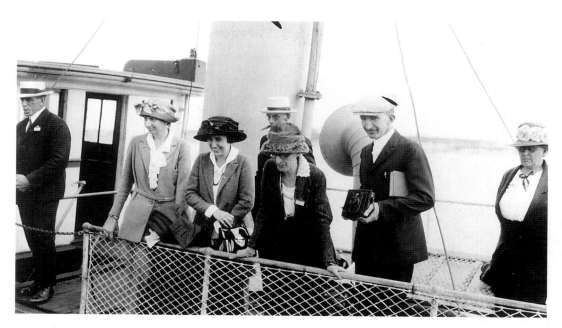

The Isles of Shoals was a scenic day trip destination on steamboats that ran from Portsmouth and Newburyport on a regular schedule. These eager visitors are approaching the dock at Star Island in the 1920s. The man with the cap is carrying a book and a camera, appropriate accessories for an island visit.

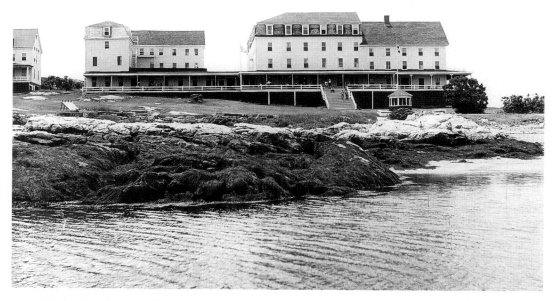

On Star Island one could see the second Oceanic Hotel, assembled from a collection of buildings in 1873-74, after the first Oceanic Hotel burned.

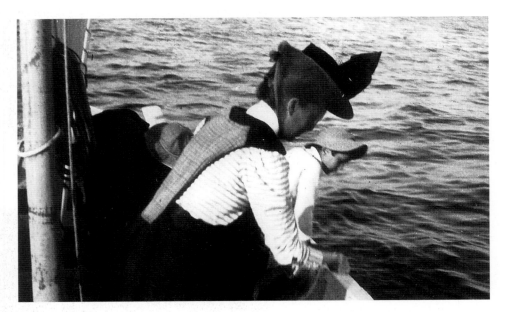

Fishing parties were very popular because most participants were successful. Many local fishermen earned extra money by conducting fishing parties on weekends. They supplied the boat, bait, and hand lines. Their customers supplied the food and drink. This photograph, taken in 1900, shows Mrs. Carleton's first attempt at deep sea fishing.

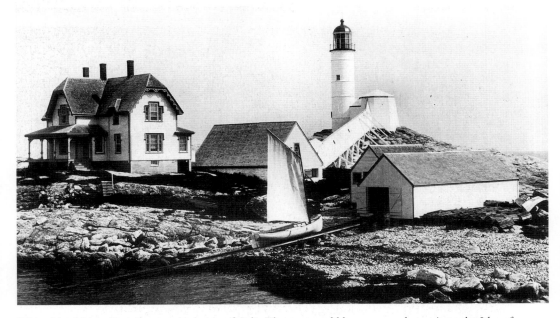

White Island Light Station, once the home of Celia Thaxter, would be seen on a boat trip to the Isles of Shoals. Celia was four years old when her father became lighthouse keeper and moved his family from a secure little house on a quiet street in rural New England to a barren island six miles from the mainland. He eventually moved the family to Appledore Island after building the Appledore Hotel. Celia married Levi Thaxter and became a respected author of prose and poetry.

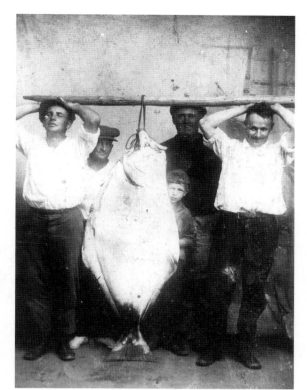

Right: A 175-pound halibut caught on a hand line from Jack Young's Gay Day. The giant fish was caught off Boon Island by E.A. Clark on 31 July 1922.

Below: Three ladies pose with their catch in 1923. They had come to pick up their husbands from one of the fishing schooners anchored just off Ocean Avenue Extension. Mrs. Anna D. Murray is sitting on the fender of the family car. On her right is Mrs. Walter Sheehan.

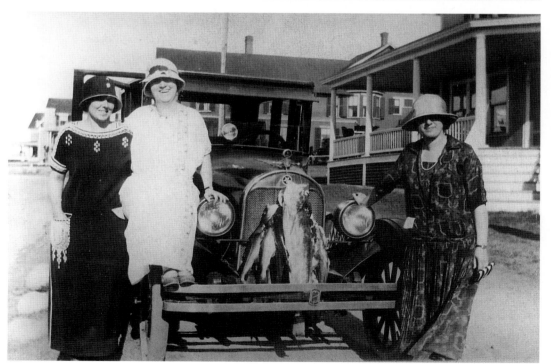

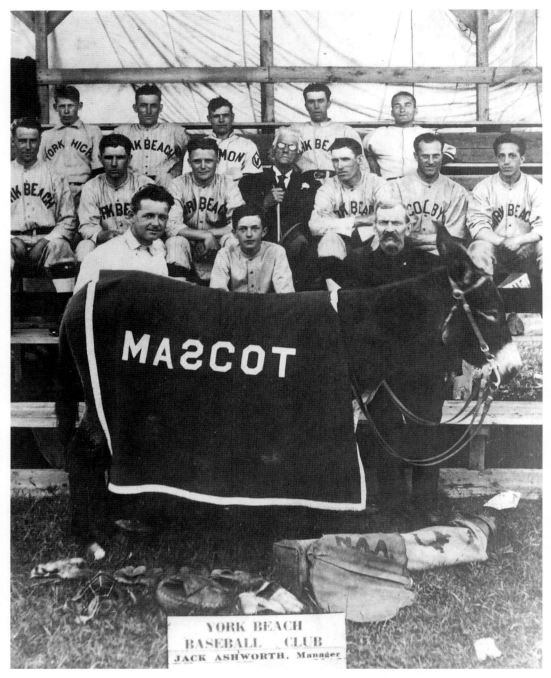

The York Beach baseball team attracted large crowds to the local baseball park when they played against teams from neighboring summer resorts and milltowns. Many of the young men were excellent college players who welcomed the opportunity to continue playing during the summer months. On 26 July 1913, the York Beach baseball team introduced Miss MacDonald, their famous girl catcher. Their mascot was a mule who might have been on loan from Colby College.

SOUVENIR
SCORE CARD

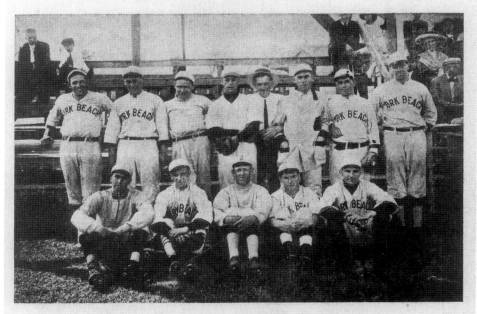

YORK BEACH
BASE BALL CLUB
1913

CHAS. F. YOUNG, Pres., Mgr.
CARROLL F. PARKER, Sec., Treas.

This line-up card featured the following names: Young, shortstop; Hayes, center field; Anderson, first base; Baxter, catcher; McKenna, third base; Morando, second base; Cavanaugh, left field; Gill or Richards, right field; Gill, Richards, Anderson or Weare, pitchers; Miss MacDonald, catcher.

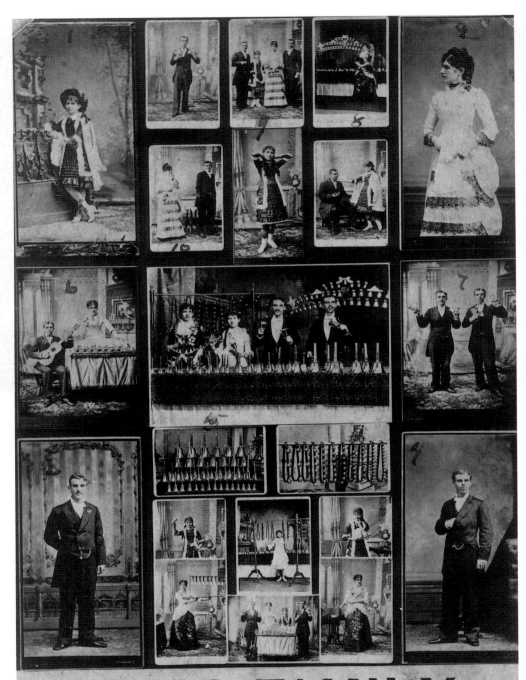

ELLIS FAMILY,
BELL RINGERS, VOCALISTS & INSTRUMENTALISTS.

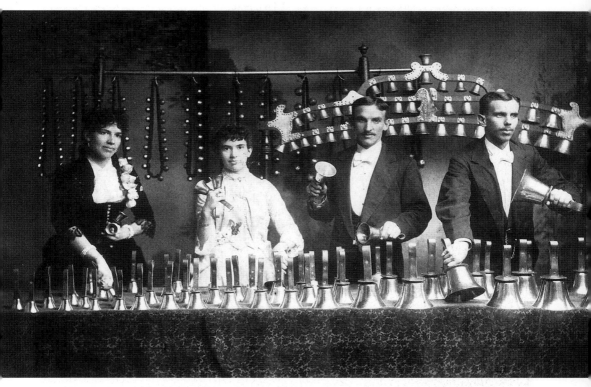

The Ellis family bell ringers in 1928. Left to right: Fannie Ellis Simpson, Romie Ellis Bowden, Frank Ellis, and Fred Ellis. The Ellis family first came to York as entertainers who billed themselves as "Bell Ringers, Vocalists, and Instrumentalists." They entertained summer visitors with sixty silver hand bells, a staff of silver bells with a hammer, and Cophopone cut-glass goblets played with wet fingers accompanied by a guitar. Fannie also played the German zither.

Opposite: The Ellis family. An advertising card showing Fannie, Romie, Frank and Fred Ellis with their instruments.

MIDNIGHT DANCE

AT

GAY WHITE WAY

BALLROOM

YORK BEACH, MAINE

ON

LABOR DAY EVE
SUNDAY, SEPT. 2, '28

DANCING FROM 12.05 A.M. TILL 4 A.M.

SPECIAL ATTRACTIONS

| Prize Waltz | Spot Dancing |
| Prize Fox Trot | Varsity Drag Contest |

PRIZES IN GOLD

CHARLIE FRIEDMAN
AND HIS BOSTON ORCHESTRA

John M. Schell, Printer 47 Hanover St., Boston

The Gay White Way was a popular ballroom. Highly regarded orchestras were engaged to play nightly in the summer. On Harbor nights, prize dances were held and the residents of York Harbor were invited to use the dance hall without interference from residents of York Beach or York Beach tourists.

Take Me To The Gay White Way

Arranged by
MARION PAYNE

Words and Music by
EDW.W. YOUNG

Copyright 1914 by E.A.Patch

"Take me to the Gay White Way" was a favorite waltz song written in 1914 and played regularly in the ballroom. The words mention all the prominent York Beach hotels including the Hiawatha, the Atlantic, the Algonquin, the Ocean House, Youngs, Fairmont, the Kearsarge, and the Rockaway. "We'll dance once again to that dreamy old strain, and hum when the orchestra plays the refrain...."

That is the place for va - ca - tion,
Hast-ings, Hia - wa - tha, At - lan - tic,
Al - gon-quin,
Wah - ni - ta,

That's where the peach-es all
There'll be a warm wel-come for

grow. Stroll-ing a - long on the board-walk, Or
all; But when you want real rec - re - a - tion, Ask

spoon-ing the hours a - way, There'll be some dear who will
some win-some maid where to go, She'll put you wise when she

breathe in your ear, And these are the words she will say,
looks in your eyes And says,"Come on, kid, don't be slow."

Take me to the Gay White Way 3

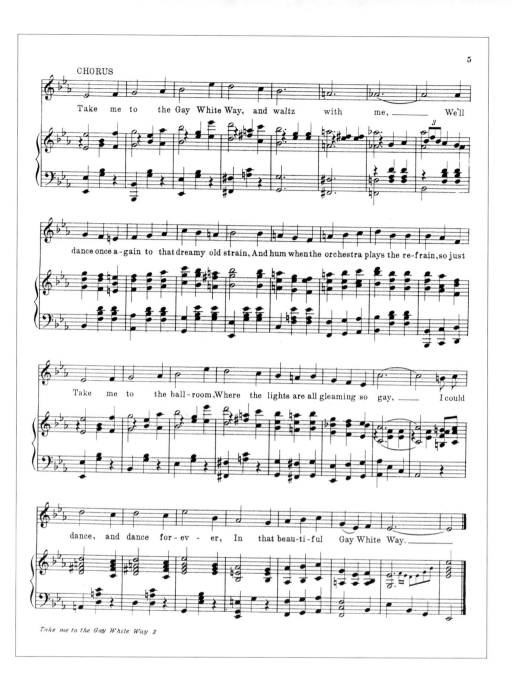

CHORUS

Take me to the Gay White Way, and waltz with me, _____ We'll
dance once a-gain to that dreamy old strain, And hum when the orchestra plays the re-frain, so just
Take me to the ball-room, Where the lights are all gleaming so gay, _____ I could
dance, and dance for-ev - er, In that beau-ti-ful Gay White Way._____

Take me to the Gay White Way 3

Gay White Way Ball Room
TO-NIGHT

Miss Alice Pinkham
Assisted by
Mr. Vernon Bennett
Direct from New York

Dancing the Chinese Ta Tao, La Rula La Rula and others.

DON'T MISS THIS OPPORTUNITY TO SEE THIS WONDERFUL COUPLE

This broadside advertised a dance team, direct from New York, who were prepared to demonstrate the Chinese Ta Tao and other dance steps.

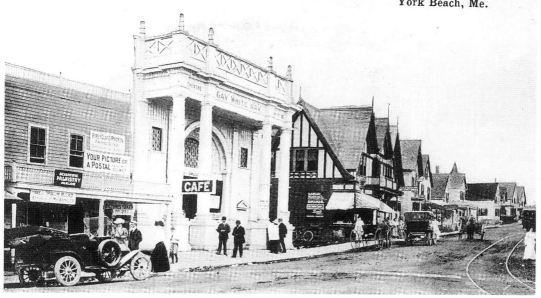

The dance hall at the Gay White Way was originally at St. Aspinquid park and was acquired by Frank Ellis in 1908-9. He moved the large building through the fields behind main street and relocated it next to Dr. Hawkes Drug Store. Ellis found the tall white columns of the entrance at Revere Beach. They were a York Beach landmark for many years.

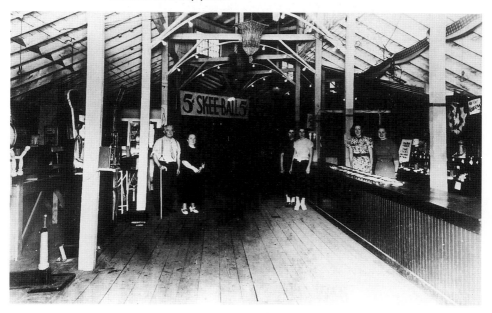

Inside the entrance on the left was a lunch counter. On the right were activities, including Skee-Ball, a fortune teller, and other concessions. Ellis added a theater wing on the right which extended behind the drug store.

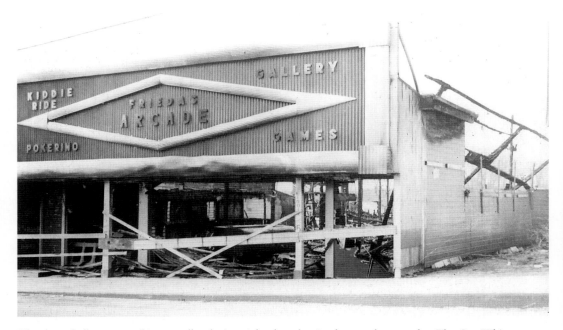

The dance hall was turned into a roller skating rink when dancing became less popular. The Gay White Way became Frieda's Arcade and the exterior was "modernized". The tall white columns were removed and replaced with an aluminum sign.

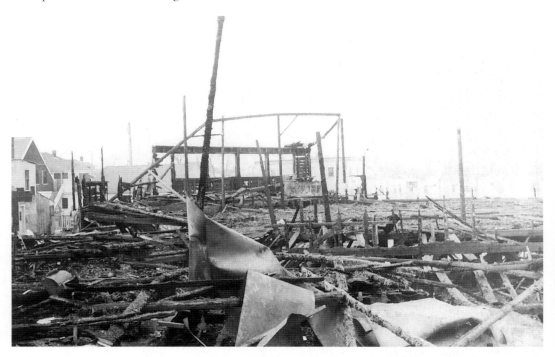

An arsonist burned the entire complex to the ground on 21 March, 1951. The fire was well advanced when the firemen arrived but they prevented it from destroying nearby buildings.

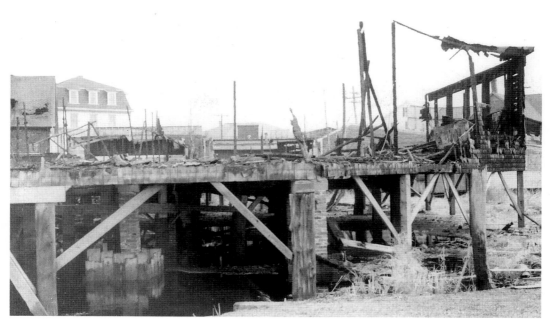

The old arcade was completely destroyed by this fire, leaving a large hole in the center of the York Beach business district.

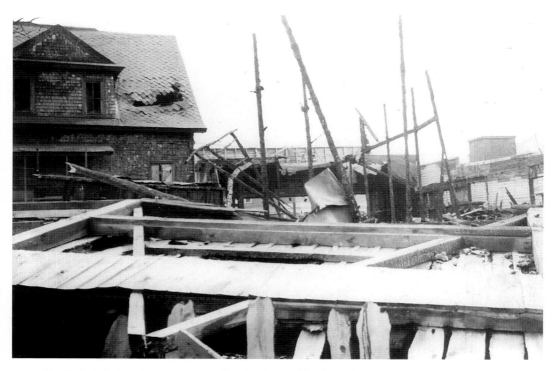

The Libby Block and restaurant were heavily damaged by fire and water.

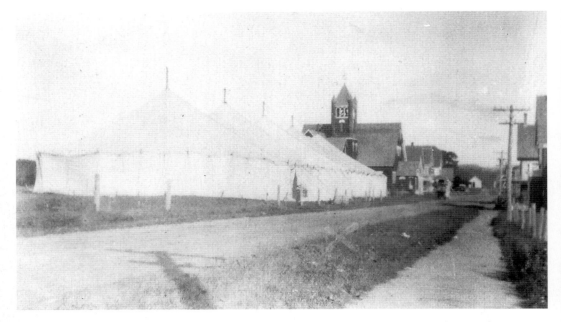

Carnivals or circuses visited York Beach during the 1920s and 1930s. This tent or series of tents is shown on the land opposite the Bowden House and adjacent to the Union Congregational Church. The picture is labeled, "Carnival on Church Street, c. 1920."

"Cole's Colossal Circus" was the first to visit York Beach. It came for one day only — 25 August 1893. Adult tickets were twenty-five cents and children under ten were charged ten cents. All evening tickets were twenty-five cents.

three

How did they get there?

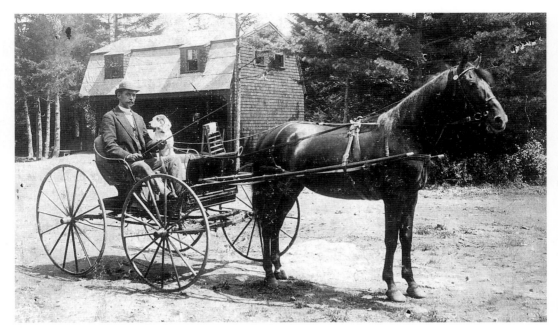

Edward N. Walker and his dog. Mr Walker was a respected employee of the Passaconaway Inn.

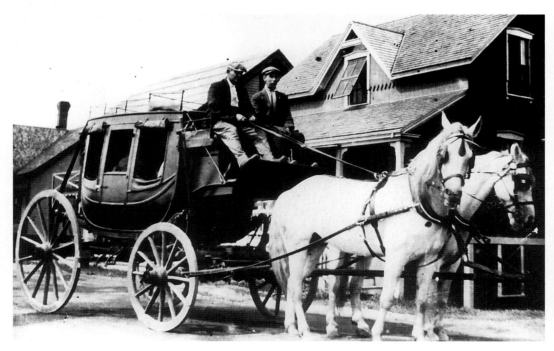

Stagecoach bringing hotel guests from the Portsmouth railroad station. The large hotels had their own coaches which were sent to meet the trains. This coach is in the vicinity of the Anchorage Hotel on Long Sands Beach. The sign on the cottage says "Whitehead".

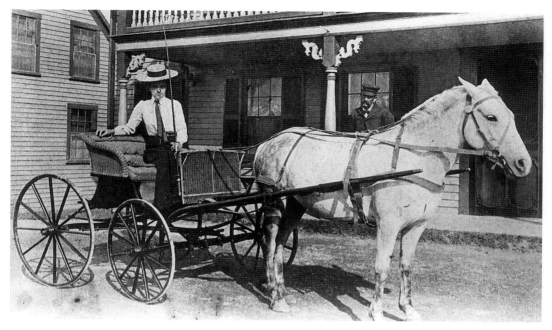

Young lady dressed for a drive. She is wearing a straw hat, necktie and long black skirt. The little horse looks strong and lively. A spirited drive along a shady dirt road in the countryside brought relief from the heat of a hot August day. There were several stables that would rent a horse and buggy for such recreation in the 1890s.

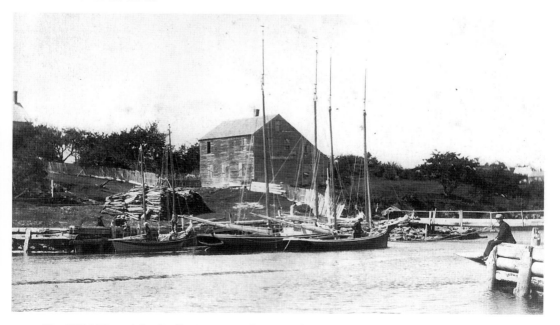

The *Will Miller* and the *Satellite* were two schooners of considerable antiquity which carried passengers and freight to and from the harbors along the New England coast. In earlier days there were many docks along the Cape Neddick River and schooners carried two-foot pine logs and crates of eggs to Boston.

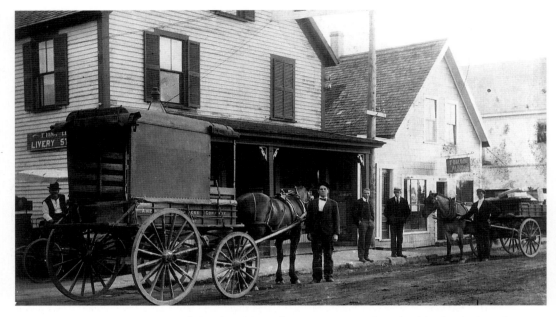

An American Express wagon in York Beach in 1905. These wagons carried much of the freight from the train and trolley stations. Cap Seavey is the man in the center of the picture. Cap worked for American Express for nearly twenty years, and at one time he worked as American Express agent for the York Harbor and Beach Railroad.

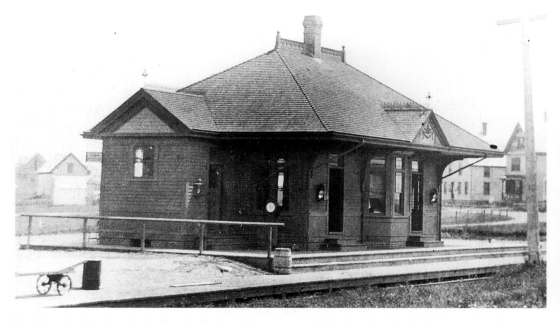

York Beach railroad station before the freight platforms were added. The first scheduled train ran on the tracks of the York Harbor and Beach Railroad on 8 August 1887. It arrived with a second locomotive on the rear of the train because the turn around was not yet in place. The fare was fifty-five cents from Portsmouth to York Beach.

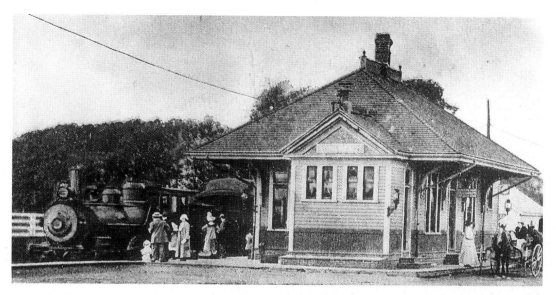

The YH & B met every Boston to Portsmouth train during the daylight hours. There were four trips each day during the summer months. The rail line was abandoned on 29 June 1925, with the exception of the spur to the Navy Yard.

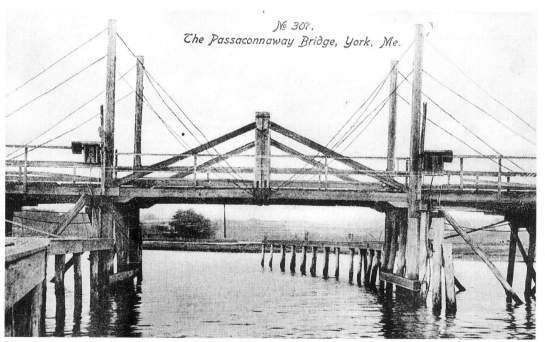

This drawbridge across the Cape Neddick River could be raised to permit schooners and fishing vessels to enter the harbor at Cape Neddick. The narrow draw was built in two sections, each half lifted by a winch with meshed iron wheels. A crank turned a big drum around which the chains of the draw were slowly wound. The apparatus was operated from two small platforms, one on either side of the bridge. The Passaconaway Bridge was replaced by a new bridge in 1923.

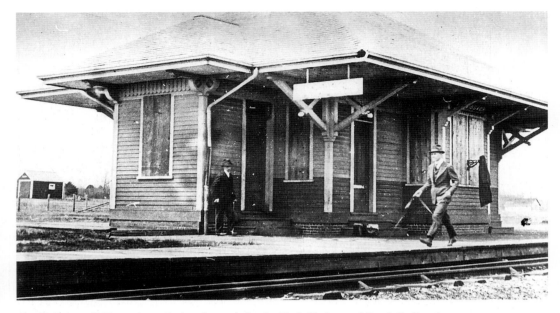

On 24 August 1887, workmen laying the track for the York Harbor and Beach Railroad were temporarily stopped by swamps one and a half miles short of Union Bluff. They stopped at Long Sands Station, temporarily named York Beach Station. It was changed to Long Sands Station when the line was completed. Later, it became Long Beach Station.

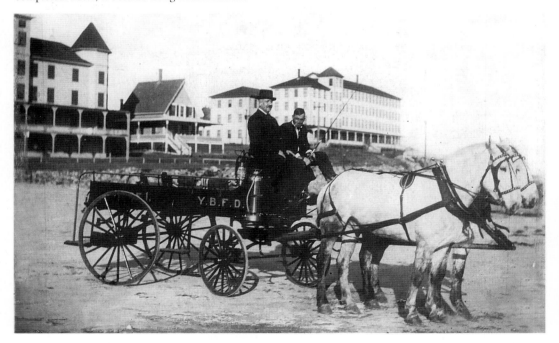

The York Beach Social Club raised $235 in 1890. They purchased a used horse-drawn hook and ladder wagon in Dover, New Hampshire, and twelve leather fire buckets from the Portsmouth Navy Yard. The York Beach Fire Department was organized in that year.

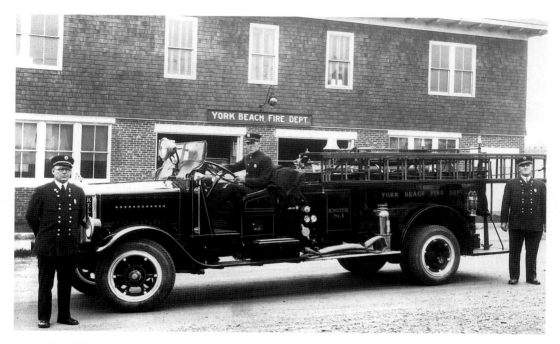

The 1928 Kelley Springfield Pumper at the York Beach Fire Station. Left to right: Harley Ellis, Lawrence Chase, and Caleb Bowden. In 1922–23, the York Beach assessors reported that the fire company was one of their best assets and should be helped out as much as corporation funds would permit.

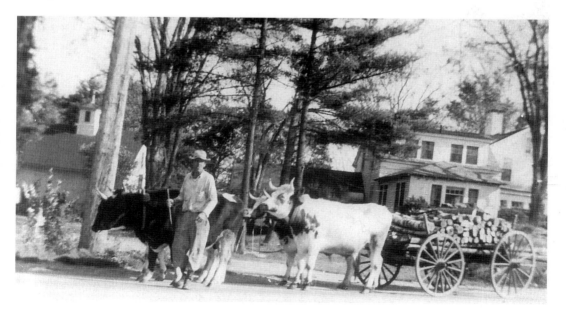

Oxen were still a common sight at the turn of the century. This local farmer is using them to haul cod wood to Cape Neddick Harbor.

A team of oxen hauling firewood. The raising and training of oxen provided farmers with a method of moving their products from the rural back country to the markets on the coast.

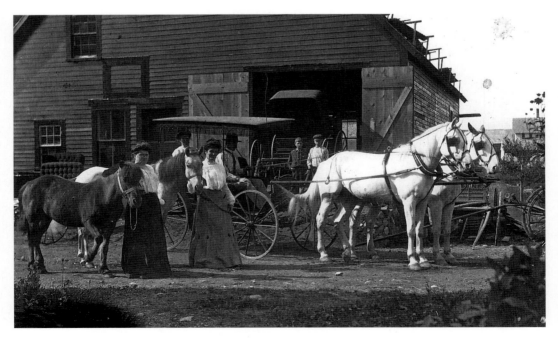

Livery stables provided horses and carriages for rides in the country. Recreational trips were promoted by hotel owners whose brochures praised the scenic beauty of the area and encouraged guests to ride to Chase's Pond, Mount Agamenticus and other rural areas.

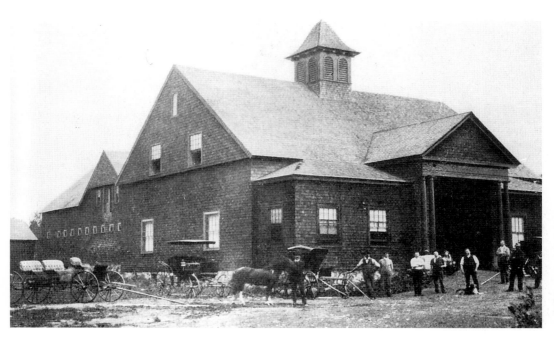

The livery stables at York Cliff were zoned to keep them away from hotels and cottages. The Passaconaway Inn provided livery services for guests and cared for horses that were owned by guests.

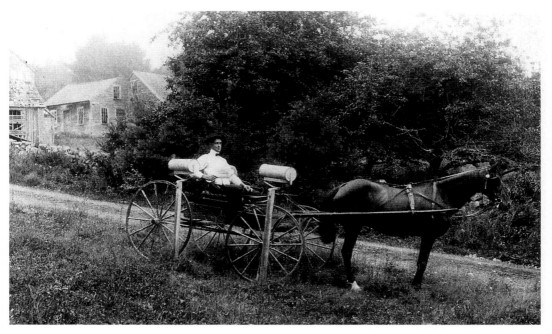

David W. Young delivering mail on one of the back roads used by summer residents seeking to "get back to nature". Mr. Young is listed as a mail carrier in the 1906 Town Register of York and Kittery.

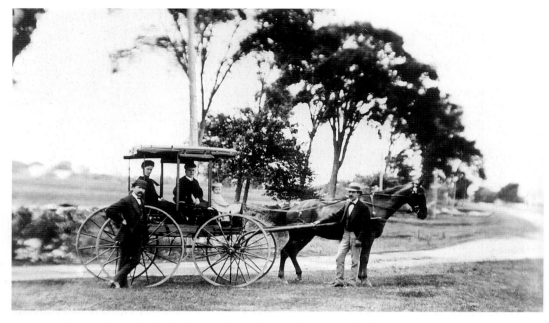

An outing in the country. Such trips frequently involved a picnic at the halfway point.

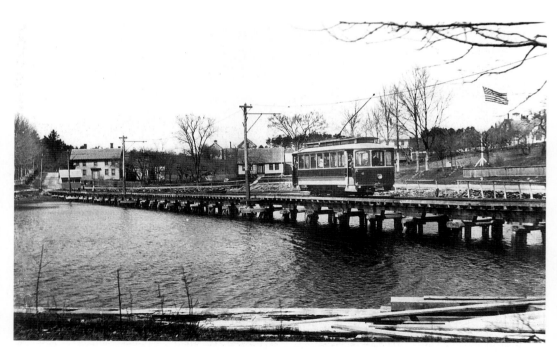

Passing Lock's Cove in Kittery on the ride between Portsmouth and York Beach. By the turn of the century, electric street railways connected all the major cities in the nation. With some three hundred thousand employees, this railway system became the nation's fifth largest industry.

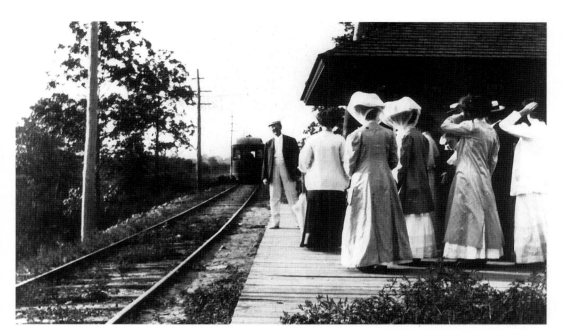

Passengers waiting at Bald Head Cliff station. In 1897 the local newspaper warned York residents that, "When an electric railway is built between a city and a country town, the natural trend of business will surely be toward the city."

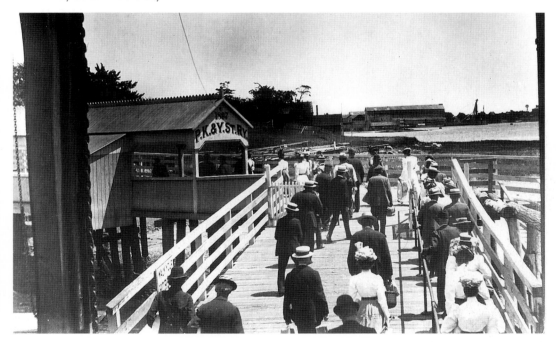

Well-dressed travelers hurry from the ferry landing at Badger's Island in Kittery to catch the electric cars to York Beach.

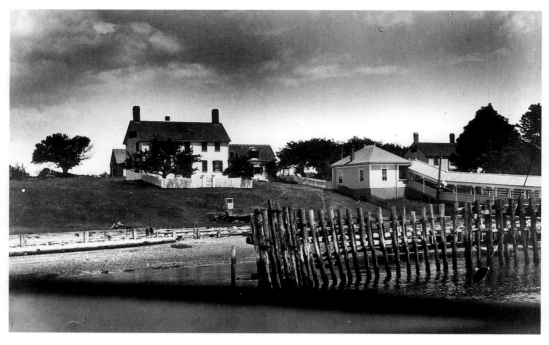

Above: The ferry landing in Kittery was often the last leg of a sometimes long journey to a summer vacation resort.

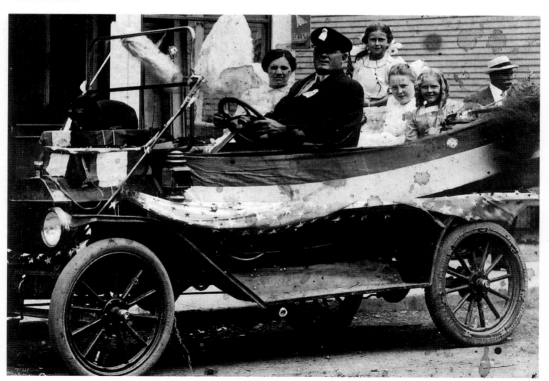

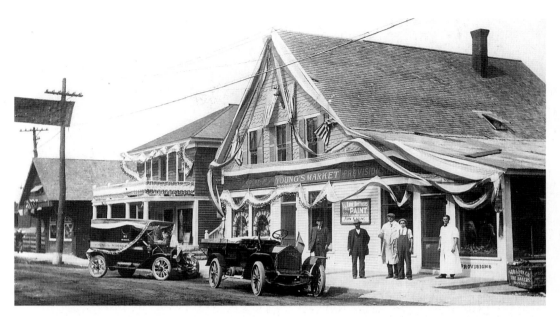

Two of the first motorized delivery vehicles in York were used by Young's Market. The grocery store, like Jack Young's vehicle, is decorated for the Bay Haven Yacht Club parade in 1910.

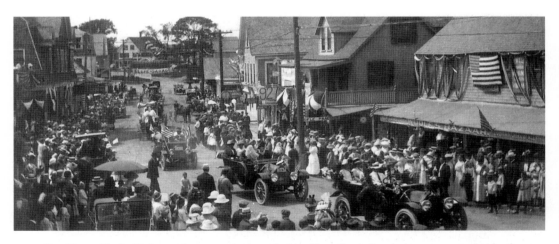

Bay Haven Yacht Club members organized carnivals at Short Sands Beach that were attended by four to six thousand people. Events included a gala parade, a motor boat race, a band concert, rowing races and fireworks.

Opposite below: John "Jack" Young, commodore of the Bay Haven Yacht Club, in his vehicle which has been decorated for a parade. Automobiles soon became an important element in every parade. Jack was one of the first York Beach residents to own an automobile and he was an enthusiastic supporter of yacht club activities.

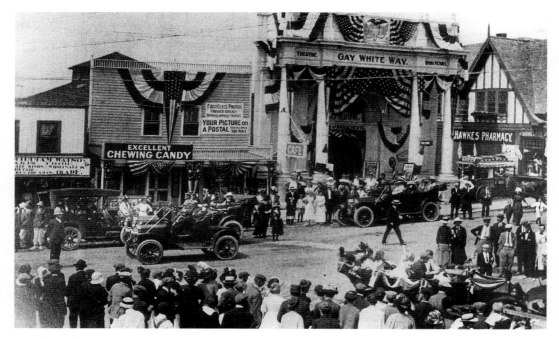

The Yacht Club was organized in 1910 to promote yachting and boating in York Beach and Cape Neddick. At its peak, the club had two thousand members and was very active in promoting York Beach as a summer resort. A large crowd gathered to watch the parade as it passed the Gay White Way in the center of York Beach.

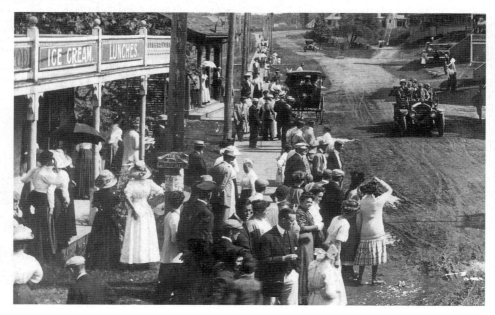

A cross-country automobile tour attracted a large crowd of spectators outside of the Goldenrod Restaurant. At that time automobiles were so unusual that the curious gathered to watch the first of the touring cars arrive in York Beach.

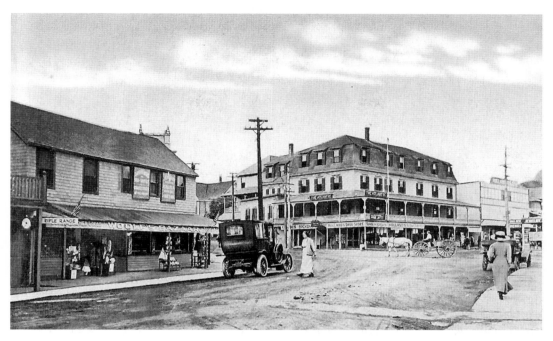

Parking was not a problem when this postcard was issued. A few automobiles, a few horses and a lot of foot traffic was the order of the day.

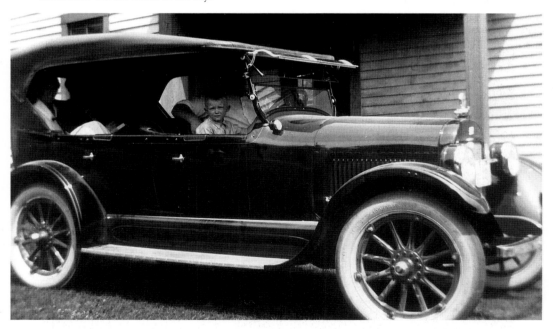

Portraits of families in their cars emphasized the important role that these vehicles played in the lives of vacationers who no longer had to remain in one location for the entire summer. Touring itself had become a way of vacationing, and it was to change York Beach significantly in the coming years. This is a 1923 Buick touring car with four cylinders.

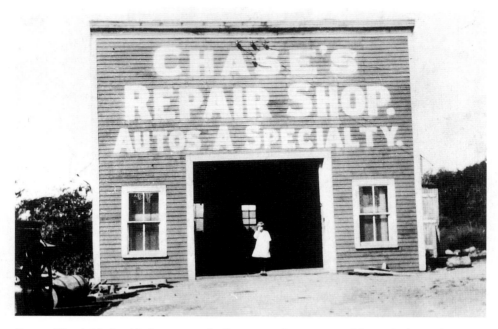

George Chase's blacksmith shop was gradually converted to an automobile repair shop as horse-drawn vehicles were replaced by automobiles on the streets of York Beach.

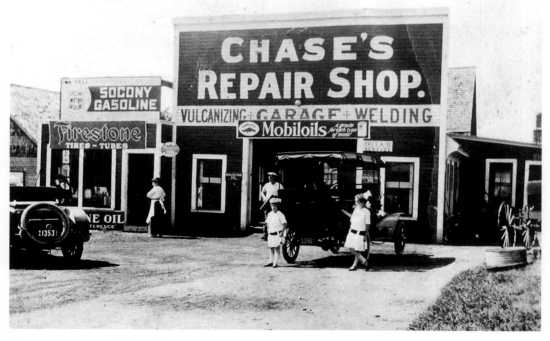

The garage was expanded to add new services as an increase in automobile traffic required fuel, oil, air, and tire repairs.

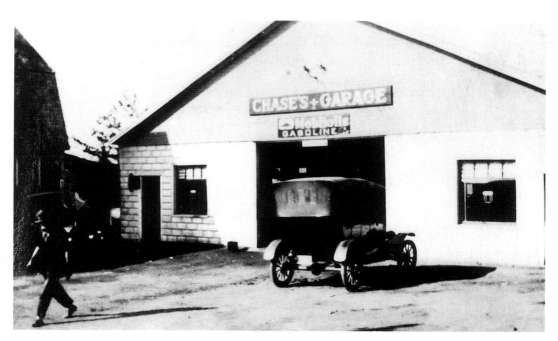

Chase's Garage was rebuilt and expanded to become a full service automobile repair facility.

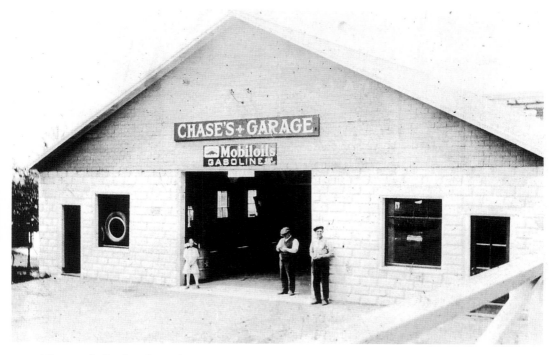

The new facility later housed an automobile dealership with sales and repair services.

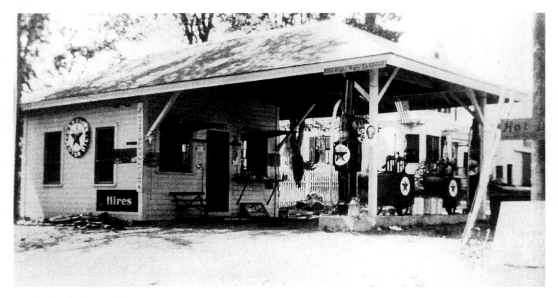

Filling stations began to appear along the most traveled routes as York Beach developed as a busy vacation resort. This is Maxwell's Filling Station in Cape Neddick. The building is now part of a convenience store called "The Cat-O-Nine Tails". Ralph Winn operated the station from the spring of 1924 through the summer of 1925. An addition which housed the take-out service was opened during the second summer. Maxwell took over the station after the summer of 1925.

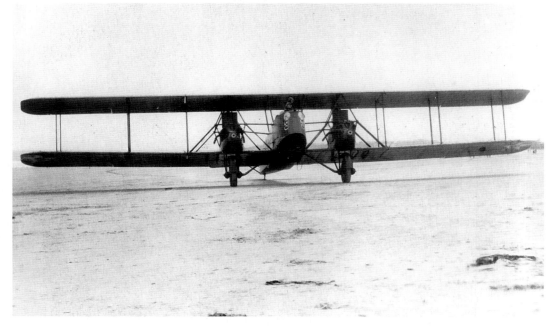

Brigadier-General William "Billy" Mitchell, founder of the United States Air Force, led his bombing squadron up the coast in August 1923. Several airplanes were landed on Long Sands Beach so that people in the resort could admire the great fleet.

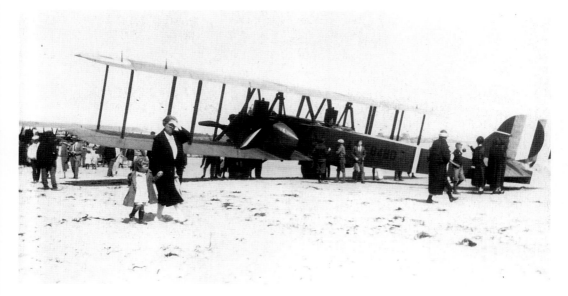

Landing the planes on the beach gave residents an opportunity to make a close inspection of the giant airships. Mitchell entered the Army as a private soldier in 1898 and was promoted through the ranks to Brigadier General by 1920.

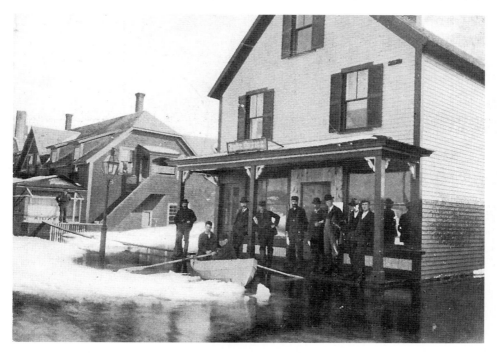

Rowboats were used in York Beach to evacuate people from the post office during one of the floods. This postcard was mailed in 1906.

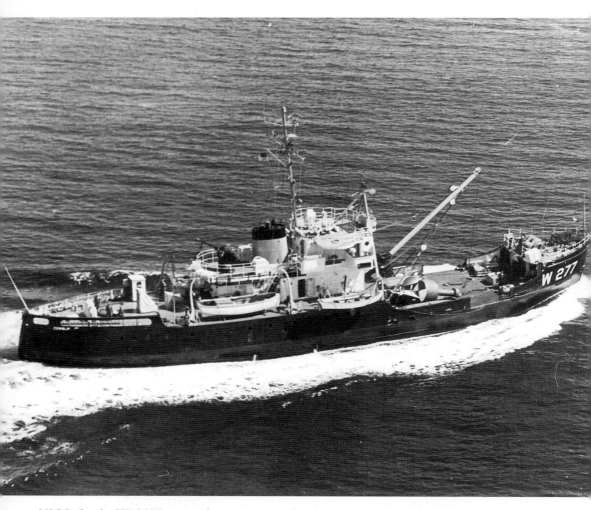

USCG *Cowslip* (WLB277) was used to transport supplies to coastal light stations, including Boon Island and the Nubble. The buoy tender delivered coal to the light stations until they were converted to diesel operation in the early 1960s.

Opposite: Crewmen of the USCG *Cowslip* lounging on bags of coal that are on their way to Boon Island. The coal was poured onto the deck of the ship and shoveled into bags by the ship's crew. Up to four tons of coal was needed at each location. Once the bags were loaded, the young men could relax on deck while they made the trip to the island.

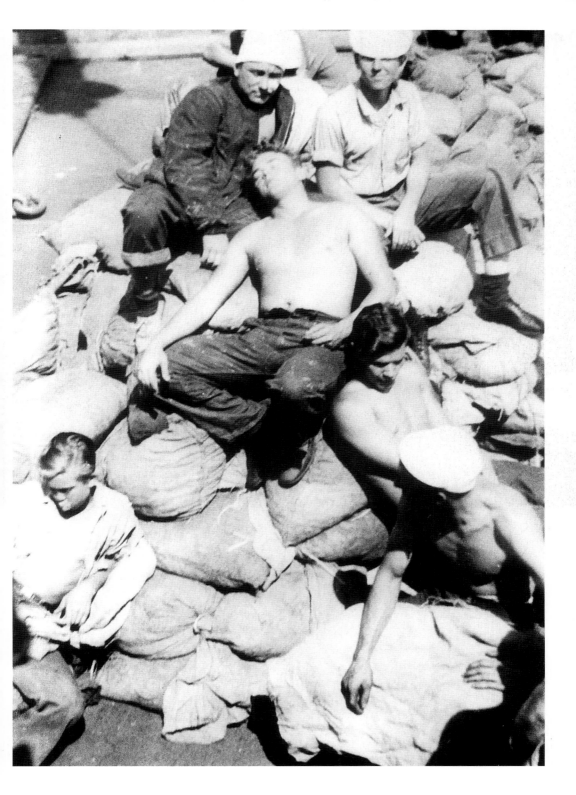

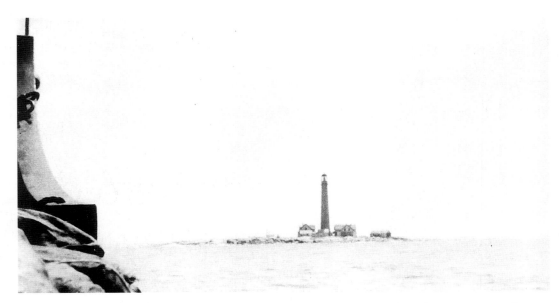

Boon Island Light Station on the horizon. There were over sixty light stations along the Maine coast and a lot of coal had to be bagged to supply them for the winter. Light keepers and their families depended on the tender to deliver fuel, food, and supplies to these remote and forbidding locations.

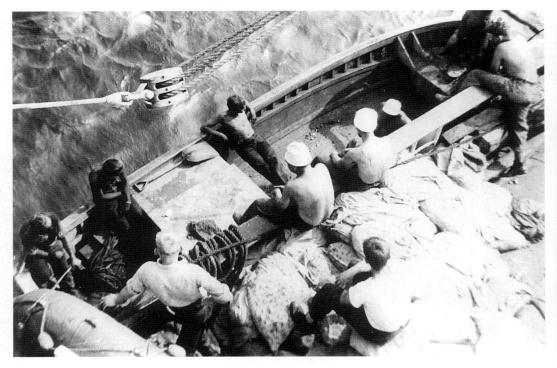

Once the USCG *Cowslip* reached its destination, the bags of coal were off-loaded into work boats that held approximately two tons. At the light station they were piled on the dock, tossed onto the shore, or winched up to the boat house.

Where did they eat?

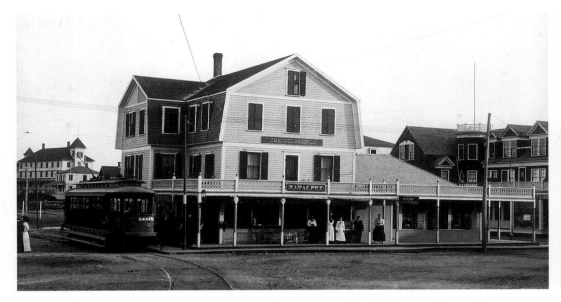

Thousands of pounds of "Goldenrod Kisses" were sold every season. The first kiss wrapping machine was acquired around 1925. Prior to that time, four to six girls would sit around a table and wrap the taffy by hand. The Goldenrod was the centerpiece of the York Beach business district and the first stop for many visitors who came on the trolley cars.

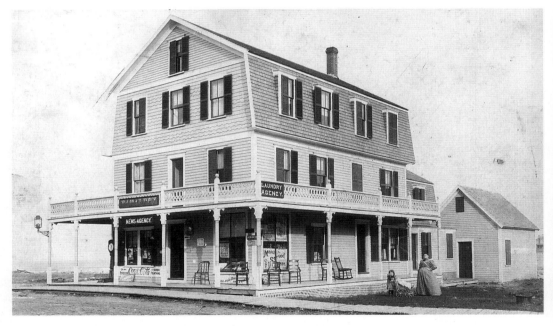

E.C. Talpey ran a farm equipment business before he purchased the Goldenrod. He sold chowder and bakery products before expanding into the candy business. In the early years, Ed Talpey made candy all day and ice cream all night. He made between six and seven thousand gallons of ice cream each season. This is the original building with an ice house at the rear. Note the wooden sidewalks which were common in the late 1800s.

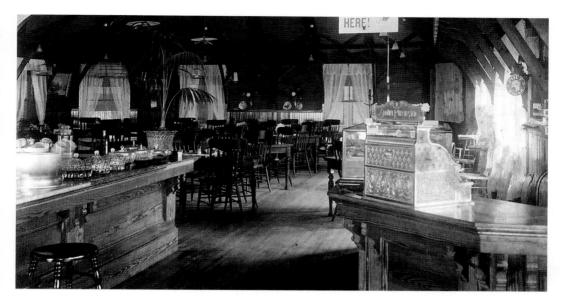

A marble soda fountain was added in the 1930s that was nearly seventy feet long. At the time, it was the biggest soda fountain north of Boston. The original soda fountain had to be polished daily with silver polish, and ice cream stored in the fountain had to be packed in salt and ice.

This street vendor sold popcorn to tourists. The cone-shaped hats were promoting the annual Rochester Fair, which was a major attraction for residents of the York area.

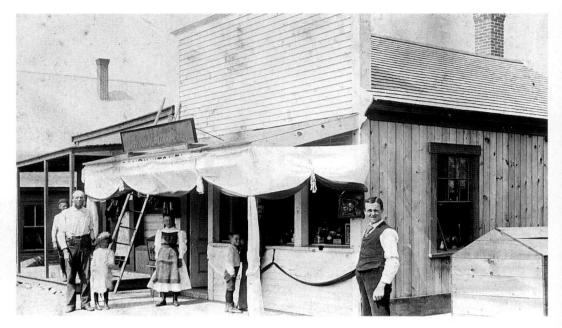

The York Beach popcorn shop is seen in this photograph preparing to open for the 1892 season.

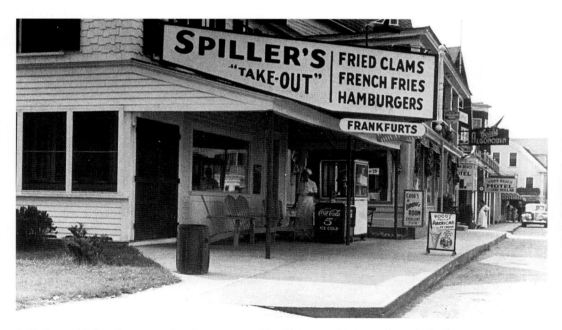

Spiller's provided a take-out service. It was operated by Alpheus and Nina Spiller. The building was expanded to add a second floor dining room to meet seasonal demand. Fried clams had some special attraction for summer vacationers. French fries, hamburgers, frankfurts, popcorn and carbonated beverages were equally popular.

The York beach assessors reported in 1922-23 that, "It is a well established fact that to accommodate the auto travel, our beach or park has to be made into a parking ground. There is no reason why York Beach should not make big gains during the next few years. The trouble in the past has been too much hot air and too little capital."

AUNT MARTHA'S
DINING ROOM AND LUNCHEONETTE

The Original
Aunt Martha

On Portland Highway, U. S. Route 1, Between York and Ogunquit

Aunt Martha's menu. One of the most popular restaurants between York and Ogunquit was Aunt Martha's Dining Room and Luncheonette. You could stop for a sandwich or a full course dinner.

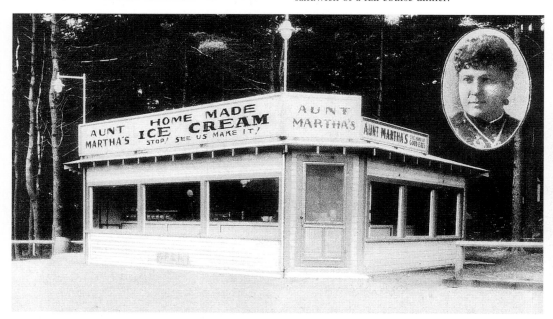

The evolution of Aunt Martha's from ice cream parlor to a full service restaurant is shown in this series of postcards.

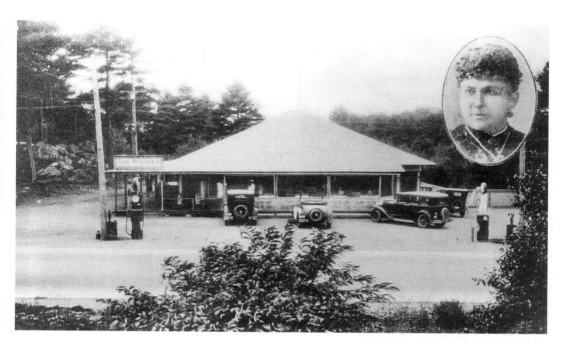

Gas pumps and a lodge were added to serve the motoring public. The manager at this time was George E. Atherton of Cape Neddick. Pastry, rolls, ice cream and candies were made fresh daily on the premises. Atherton advertised "cooking and refrigeration done by electricity".

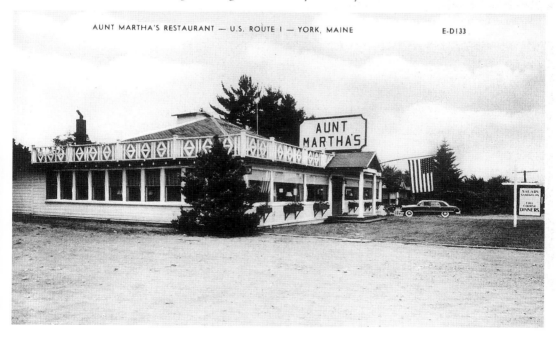

AUNT MARTHA'S RESTAURANT — U.S. ROUTE I — YORK, MAINE E-D133

In later years the restaurant was redesigned with a large dining room. The gas pumps were replaced by a large parking lot. When it was sold in 1960, it was requested that the new owners not use the name "Aunt Martha's" and it was changed to "Surfwood."

The Triangle Lunch

Cape Neddick
York, Maine

The Triangle Lunch was built by Octavius and Velma Talpey in 1926. It was located near the present site of the Cape Neddick Inn and was named from its location on a triangle of land where two highways met.

MENU

SOUPS, 15c

Chicken Beef Tomato Vegetable

SALADS

Lobster 75c	Fruit 40c		
Chicken 50c	Crabmeat 35c		
Egg 35c			

SANDWICHS
Toasted, 5c extra

Club 40c	Ham 15c
Lobster Salad .. 35c	Lettuce 15c
Chicken Salad .. 30c	Am. Cheese 15c
Plain Chicken .. 25c	Fried Egg 15c
Crabmeat 25c	Egg Salad 15c
Peanut Butter 10c	

EGGS

(2) Eggs with Bacon	45c
Dropped Egg on Toast	20c
(2) Eggs, Fried or Boiled	30c

FRANKFURTS 10c

Home-made Cake 10c Doughnuts 3 for 10c

Home-made Pie . 15c

BEVERAGES

Milk 10c

Hot Coffee 10c	Hot Tea 10c
Iced Coffee 15c	Iced Tea 15c
Fresh Fruit Orangeade .. 15c	
Fresh Fruit Lemonade 15c	

ICE CREAM

Chocolate 10c	Vanilla 10c
Chocolate Walnut Sundae . 15c	
Pineapple Sundae 15c	

Miss Nilsson's "Made-at-Home" Candies

Velma Talpey was famous in the area for her doughnuts and her chocolate cake. The same chocolate cake recipe was later used in Spiller's Restaurant in York Beach.

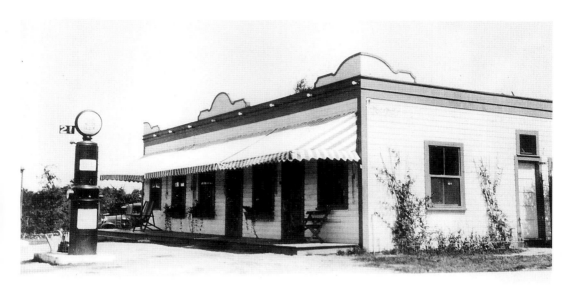

The original Triangle Lunch was a single story structure with a gasoline pump where you could fill your tank for twenty-one cents per gallon. The Triangle was purchased by Alpheus and Nina Spiller in 1929. They enlarged the dining room and opened as "Spiller's Inn" in 1930. The inn featured white table cloths, home grown vegetables and home made relishes and jams. The Spillers later sold the business and opened a new restaurant in downtown York Beach.

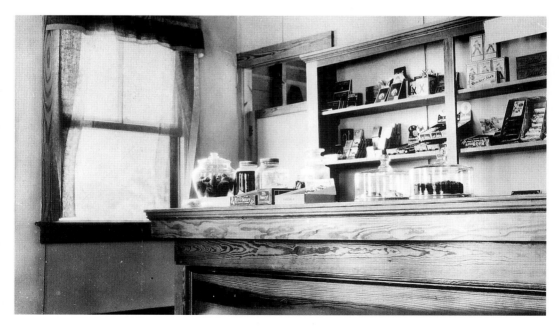

Doughnuts were three for ten cents and a walnut sundae was just fifteen cents in 1926. Candy bars, Cracker Jacks and other treats were sold at the counter.

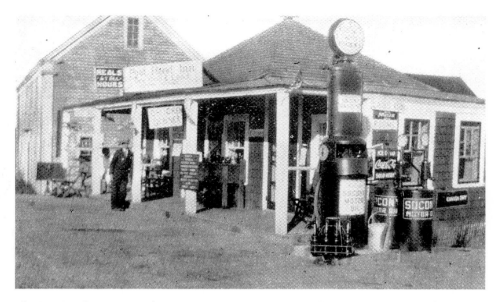

The Post Road Inn was another US Route One service center that evolved into a restaurant. The heavily traveled road was widened and paved with concrete a few years before the First World War.

The Chick-Inn, a home converted to a restaurant, was located on US Route One (also known as the New Post Road) near the present site of "Flo's" hot dog stand.

Five

What did they see?

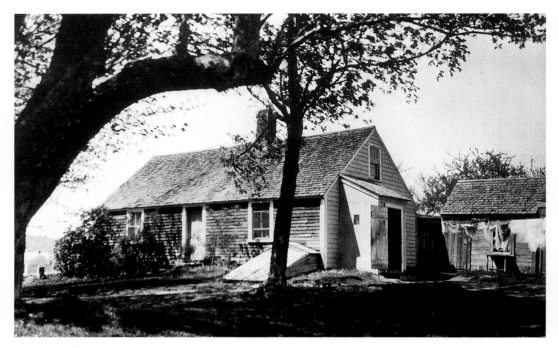

The Old Welch Place on the Mountain Road was built by Paul Welch Senior in the 1740s. Summer residents frequently toured the hill country to see the homes of early York families.

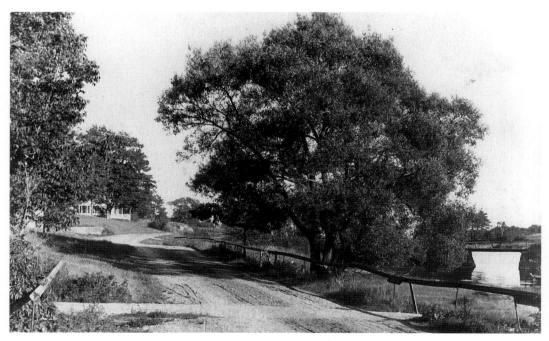

The road by Cape Neddick River was unpaved and a primitive fence marked the edges of the right-of-way. Wooden bridges spanned the small streams that flowed into the river.

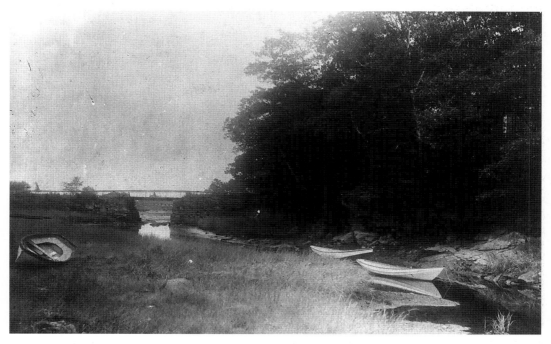

Small boats used by local fishermen floated peacefully in the small stream or were pulled up on the river bank. Here and there were rough buildings used to store fishing gear, bait trawls, or built lobster traps.

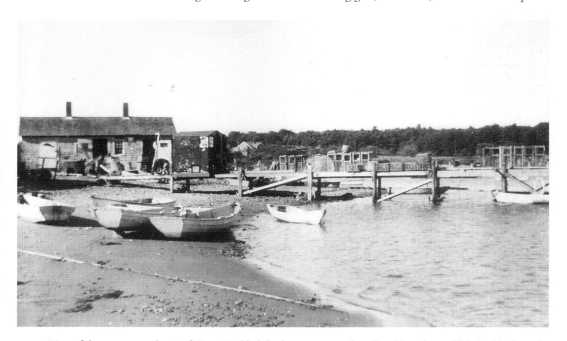

Many fishermen rowed out of Cape Neddick harbor to set trawls or hand line for codfish, haddock, and halibut. The fishermen usually worked in pairs in a small open boat. The work was hard and the weather could be punishing.

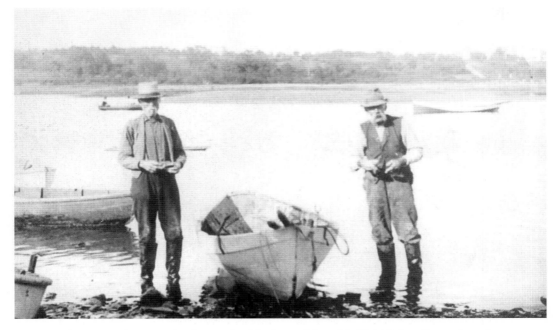

George and Hart Hutchins were local men who fished out of Cape Neddick Harbor. In good weather they could fill the boat with fish but the wholesale price was only a few cents per pound. Fish peddlers came to the harbor to buy from the fishermen and larger dealers supplied the fish markets in neighboring towns.

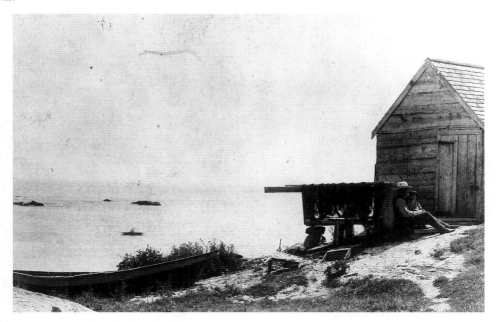

An idealized view of the life of a fisherman in the late 1800s. The area was probably tidied up before the picture was taken because it shows none of the litter that typically surrounds a fish house.

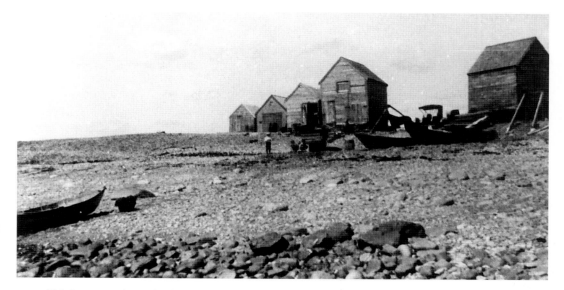

Fish houses on the rocky shore of Lobster Cove. The boats were pulled out of the water with a winch. The crude buildings were where the fishermen stored bait, trawls, oars, lobster traps, foul weather gear, boots, barrels, rope, spare hooks, weights, and other fishing equipment.

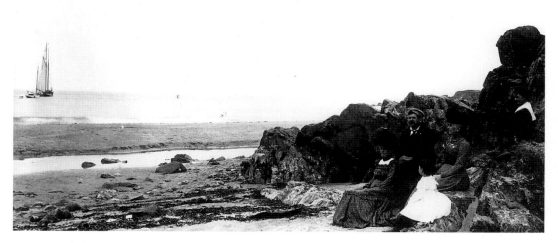

A well-dressed family group on the rocks at Short Sands Beach. A fishing party boat can be seen in the distance.

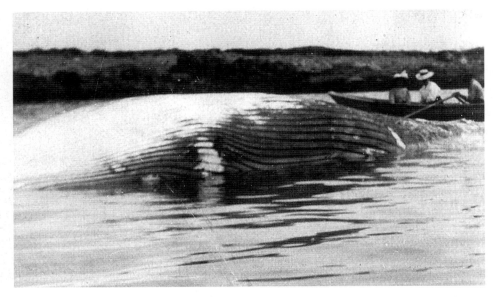

A dead whale floated into a cove on the shore road in 1902. Two or three dories were available to row people out for a closer look. The whale was towed out to sea when it began to bloat and give off an unpleasant odor.

Chase's Pond, c. 1900. Hotel brochures usually praised the local water supply and encouraged guests to enjoy a scenic ride up to the pond. This scene is near the dam that Josiah Chase built at the outlet of the pond.

Tree-lined country roads led to Mount Agamenticus where vacationers could enjoy a picnic and an excellent view of the Maine coast.

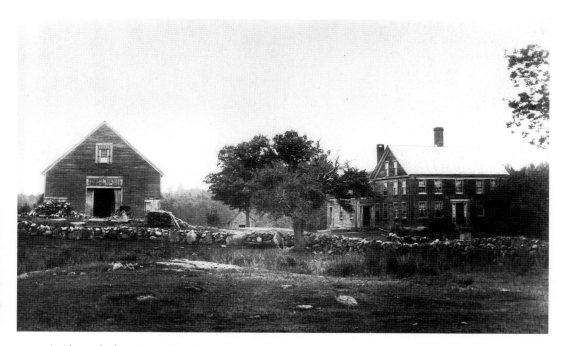

A ride up the logging road would take vacation travelers past Clay Hill Farm, now the location of a restaurant of the same name. The house in this picture burned to the ground and was replaced by a smaller building which was renovated to house the restaurant.

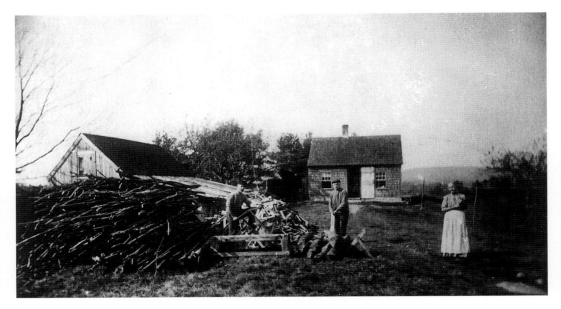

Mountain farms were small and their owners had to struggle to survive. These men are cutting and splitting wood to heat their small house during the winter.

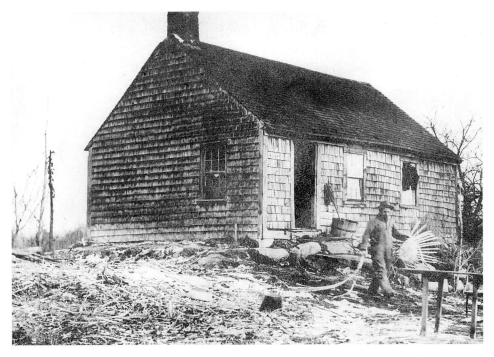

Many of the mountain residents were basket makers who traded their baskets for staples at the nearest country store. An ax, jackknife and drawshave were the basic tools needed to fashion baskets from ash or red oak logs. These baskets were made in many sizes but the most common ones were half-peck, peck, half-bushel and bushel.

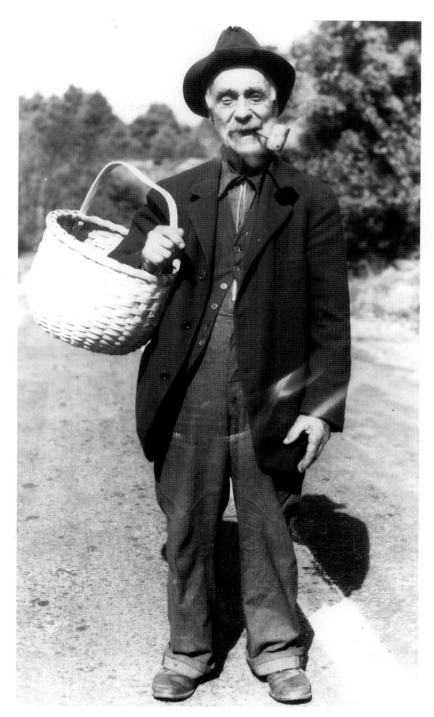

Elisha Lewis was one of the basket makers who came down the mountain to sell his baskets in coastal towns. He had a booming voice and one could trace his route down the mountain by listening to his shout.

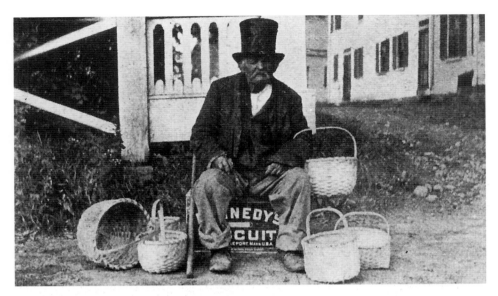

Calvin Plaisted was another basket man who used to peddle on foot and would cover a radius of twenty miles. It has been said that he attached so many baskets to his body that he looked like a moving pile of baskets as he walked down the road. He combined his peddling with begging and he gathered old clothes as he disposed of his baskets.

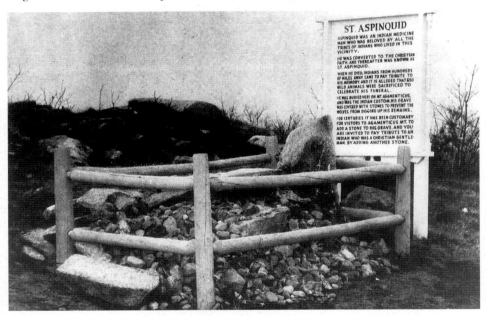

Saint Aspinquid was born in 1588, of the Pawtucket tribe which was of the powerful Algonquin family. In 1631, at the age of forty-three, he came under the influence of John Eliot who converted him to the Christian faith. He spent the rest of his long life spreading the word of God among the Indians. Saint Aspinquid died in 1682, at the age of ninety-four, and his funeral on Mount Agamenticus was conducted with great ceremony. According to the legends, 6,723 animals were sacrificed to his departed spirit.

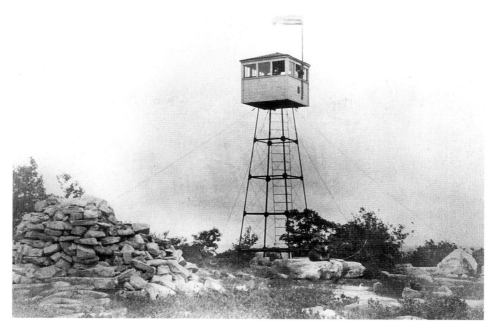

The fire tower on the summit of Mount Agamenticus was a favorite destination for hikers and outdoor adventurers. From the tower, they could see for miles in all directions.

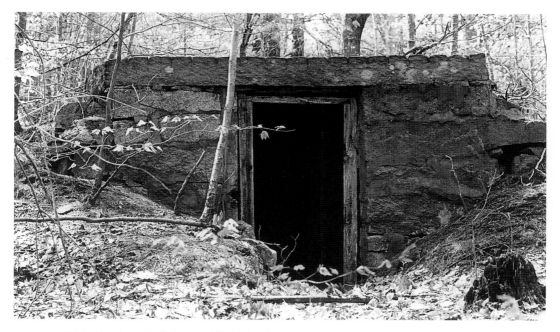

Franklin's Tomb was built for Franklin Plaisted on a now-abandoned road near Mount Agamenticus. The tomb was built around 1900 but Franklin lived out his years at the Town Farm and was probably buried in an unmarked grave near the edge of the Town Farm property. The tomb remains empty to this day.

The Ramsdell farm was another of the small farms that could be seen on a ride up the Mountain Road.

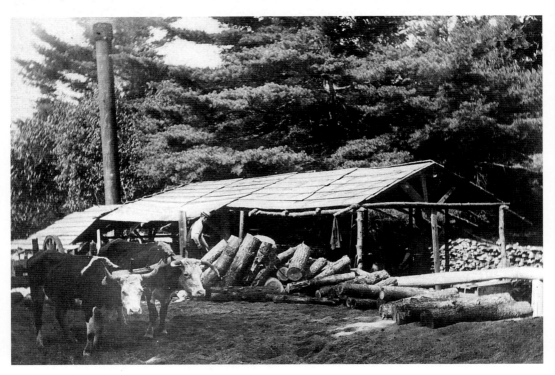

An operating sawmill was another common sight on the road. The patient oxen are waiting to help with the work.

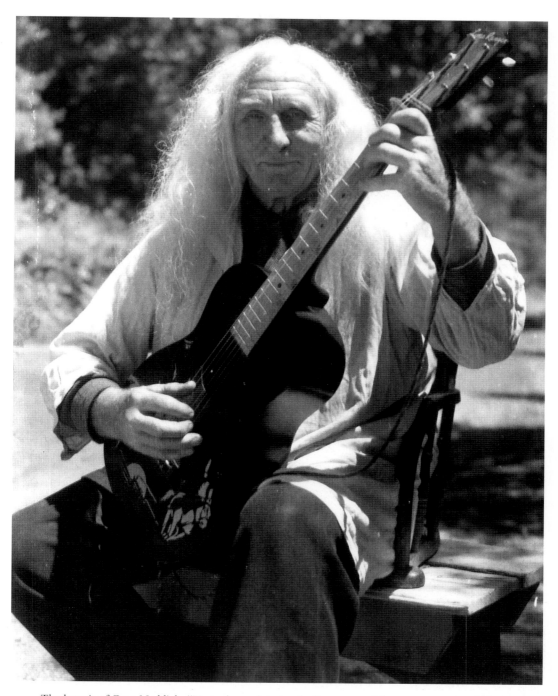

The hermit of Cape Neddick. "Twice burned, twice shy," was one of the many mottoes of Albion L. Clough, self-styled "world's champion woman hater", who lived in the Ark of Maine on the edge of Cape Neddick Harbor during the 1930s.

The hermit's home was converted from a twenty-eight foot sailboat drawn up from the beach. Visitors came from all parts of the country to chat with this cocky, self-confident rebel.

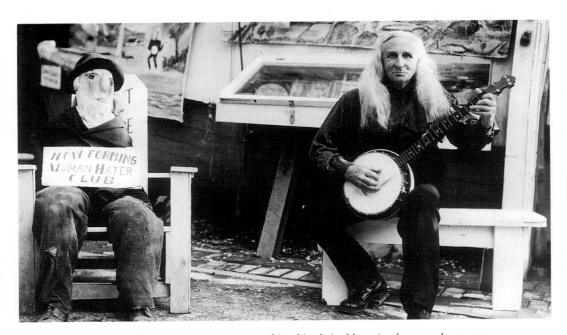

Famous people, many of them women, came to see this white-haired hermit who was a hunter, trapper, and fisherman before he moved to this area from Brighton, Maine.

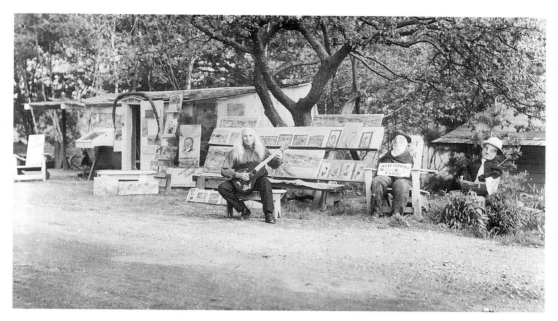

Clough's paintings were done in vivid colors with bold sweeps of the brush. His primitive landscapes were particularly interesting. Sales of paintings and postcards were his major source of income.

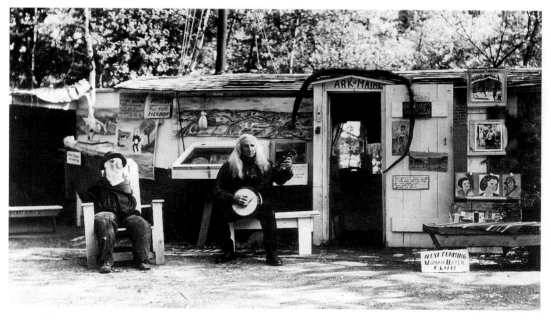

"The less men think the more they talk" and "Empty barrels make the most noise" were two of his mottoes.

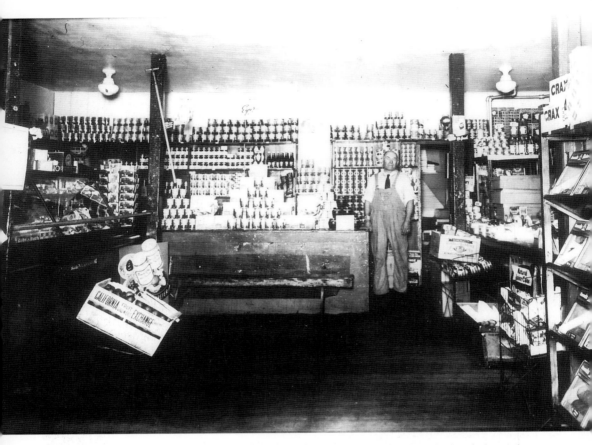

Nelson Hutchins' store was the business center of Cape Neddick and was well-stocked with the staples needed by the families in that area. They also went there to refill jugs of molasses, cider and vinegar from the barrels in the store.

Opposite below: The Hutchins store was also a center of political activity where the regulars gathered each evening to debate local issues and advise Mr. Hutchins on how to carry out his duties as selectman. Left to right: Nelson Hutchins, Stanley "Dick" Matthews, and "Ellie" Phillips.

Right: Nelson Hutchins served as a York selectman for twenty-four years. He took over the general store in Cape Neddick from Almon Merrow in 1915. Just before gasoline rationing in the early 1940s, Hutchins estimated that five to seven thousand cars were passing his store during the summer season.

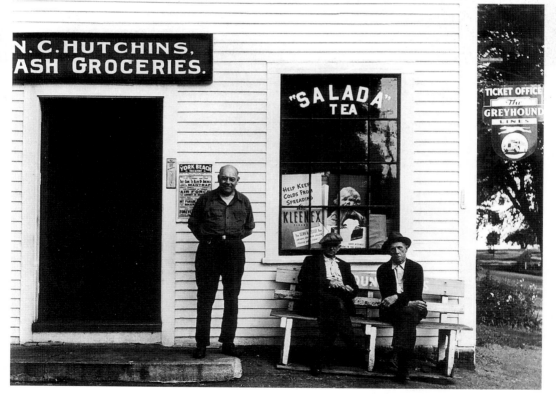

Maxwell's boarding house and cabins were adjacent to the Hutchins store. This business evolved with the increase in traffic on US Route One.

Cape Neddick Corner when there was no traffic to disturb the quiet beauty of the area.

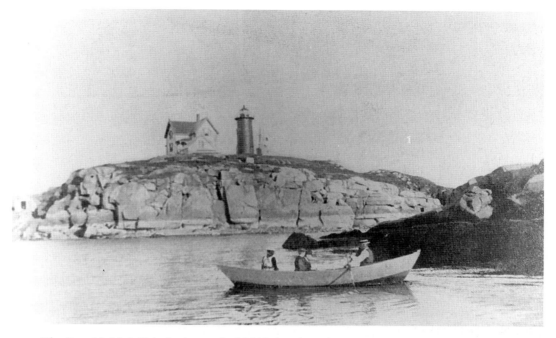

The Cape Neddick Light Station on the Nubble has always been a major attraction for sightseers. This group probably rented a boat to row out and see the lighthouse. This is how the station appeared in 1890. The tower was painted white in 1902 and covered walkways to the tower and bell house added in 1911.

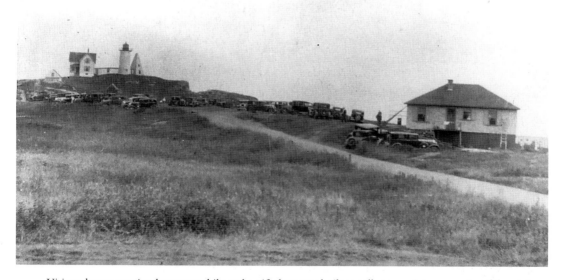

Visitors began coming by automobile and a gift shop was built to sell appropriate souvenirs of the visit. The gift shop was burned by an arsonist.

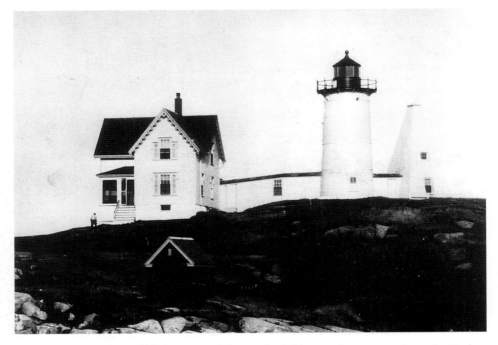

The lighthouse on the Nubble has attracted thousands of visitors each summer and remains York Beach's most significant landmark. This photograph shows a bell tower on the right which was built in 1911 and removed in 1961.

Frank Coupe built a restaurant and lobster pound at the approach to the Nubble light station. At that time there were few cottages on the peninsula. Coupe's Lobster Pound was a popular eating place during the 1930s and early 1940s.

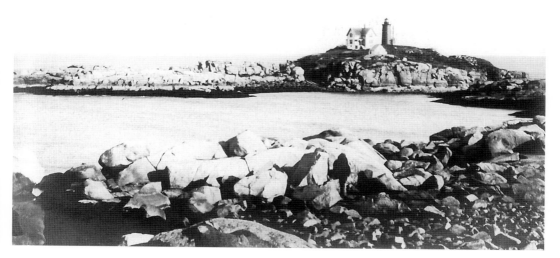

The light tower was painted black for a brief period. This early postcard shows only the house, workshop and light tower. The tower was painted black when it was constructed in 1879, and the open structure bell house added in 1880.

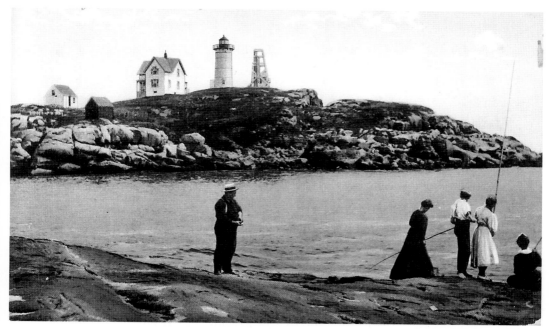

An open-structure bell house and an oil house have been added in this postcard. The oil house was built in 1902 and the tower was painted white. The white barn was built in 1905.

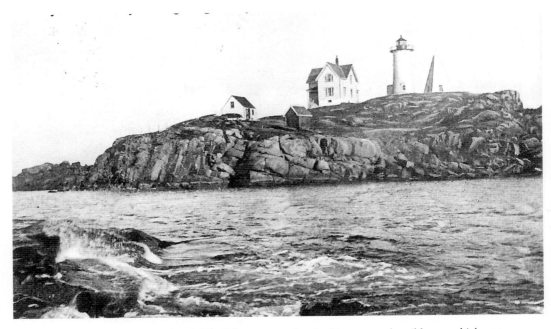

Later, the bell tower was covered and all buildings were painted white except the oil house which was traditionally painted red.

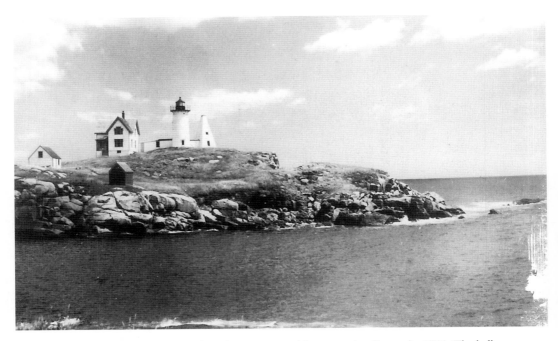

The light tower, house and bell tower have been connected by covered walkways by 1911. The bell tower and connecting walkway were removed in 1961.

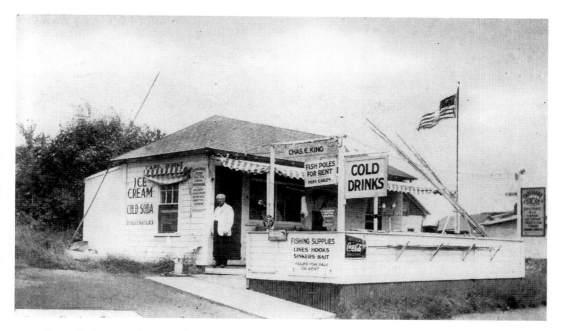

James Burke was a former lighthouse keeper who served on Boon Island, Burnt Island, White Island and the Nubble. He worked at the Nubble from 1912 to 1919 when he retired and built this store adjacent to his home near the light station. He rented bamboo fishing poles and sold bait, fishing supplies, ice cream and cold drinks.

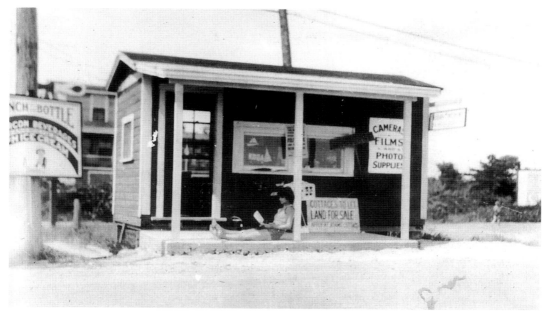

This camera shop, at the intersection of Ocean Avenue and Long Beach Avenue, was operated by Oliver Adams who lived in a cottage behind the shop. Darkroom facilities were in the cottage. This photograph was probably taken in 1925 when Adams' father was the station master at the Oceanside railroad station.

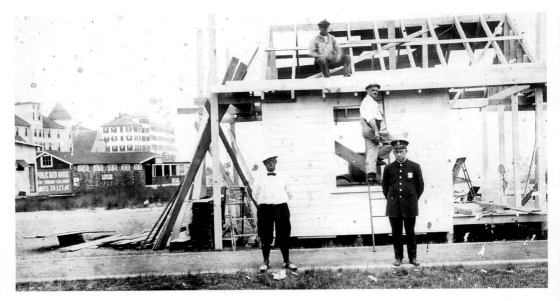

A chamber of commerce building was constructed near the boardwalk in York Beach in 1926. It served summer visitors and businessmen for over fifty years. The little white building with the green trim was destroyed in the terrible storm of 1978 when waves pushed it from its foundation and washed it across the street. The damage was so severe that there was no attempt made to repair it.

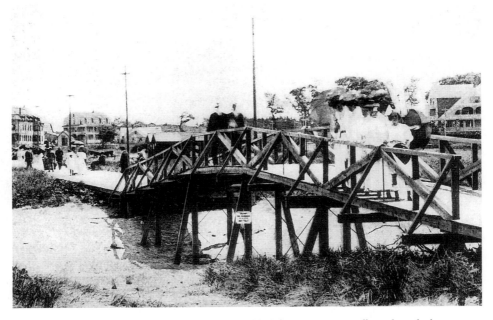

This footbridge for fashionably dressed strollers enabled them to cross a gully and reach the boardwalk at Short Sands Beach. It was at the site of a brook that ran past the bowling alley until it was routed through a penstock, or culvert.

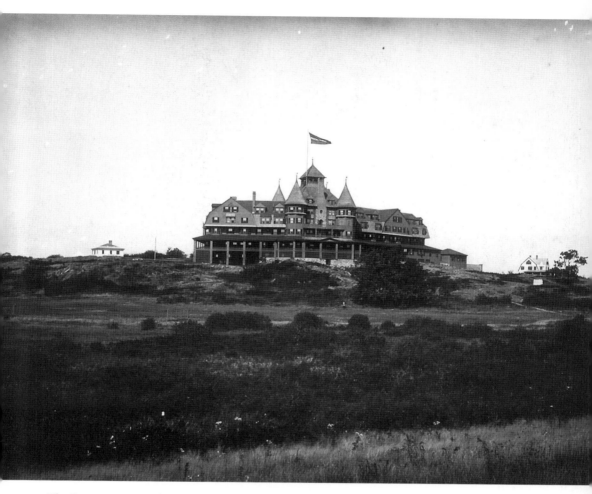

The Passaconaway Inn loomed high on York Cliffs looking like a beautiful fairytale castle for over forty years. Opened in 1893 and closed in 1937, it had towers and dormers, balconies and wide porches facing the Atlantic Ocean. The building was a splendid example of the shingle-style architecture that was so popular in this area. From the porches of the inn one could see the lighthouse on Boon Island Ledge, and across the tidal river and bay was the famous Nubble Light. On the west were the three peaks of Sasanoa, the name given by Captain John Smith to Mount Agamenticus. It was generally believed that Saint Aspinquid, who was buried on Mount Agamenticus in a great tribal ceremony, was Passaconaway, chief of the Pennacook Confederation. This may be the reason for naming the new hotel the Passaconaway Inn.

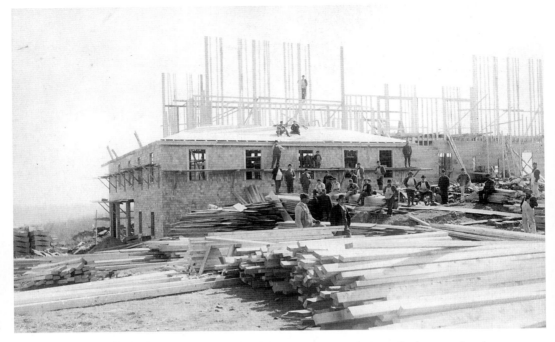

March 24, 1893. This is the first of a series of remarkable construction photographs documenting the building of the huge Passaconaway Inn complex.

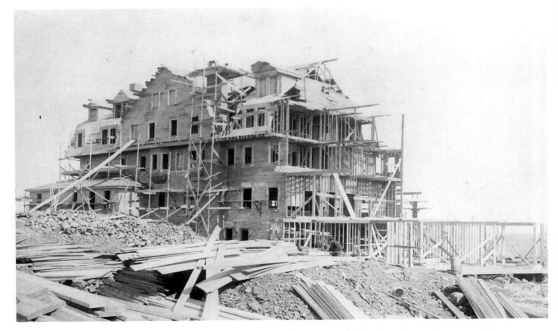

April 5, 1893. Hotel construction provided employment for an army of local workers who erected the buildings in record time.

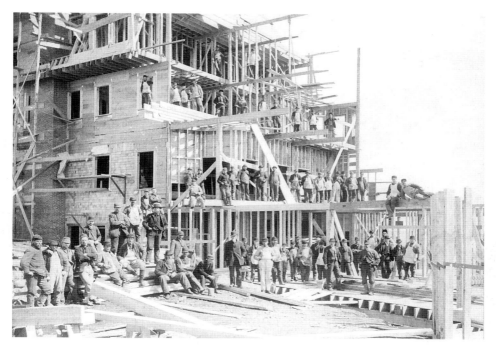

April 5, 1893. The construction site was like a beehive, with a swarm of laborers involved in all phases of the project.

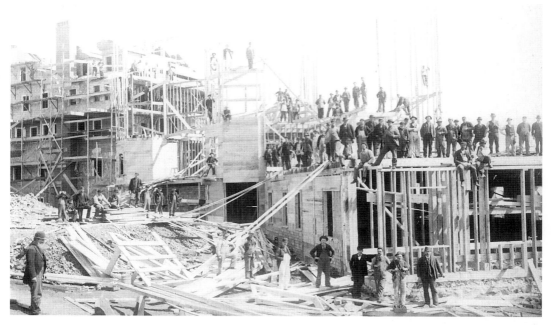

April 12, 1893. The availability of cheap labor made it possible to assemble the vast manpower necessary for such a project.

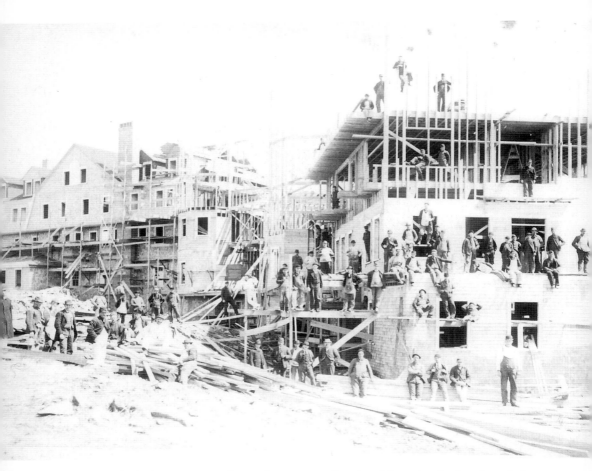

April 19, 1893. The building just seemed to evolve as teams of workers followed each other through the construction project. The York Cliffs Improvement Society constructed the inn, which was the only commercial building allowed within the boundaries of the property.

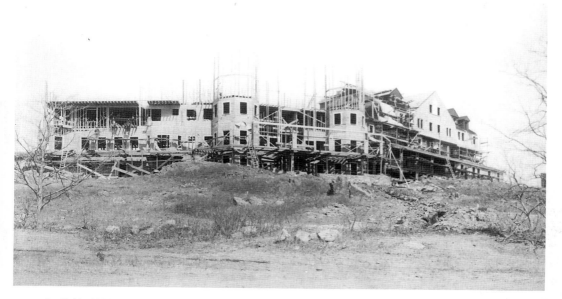

April 19, 1893. A New York syndicate led by John D. Vermuele and Adrian Vermuele financed the project.

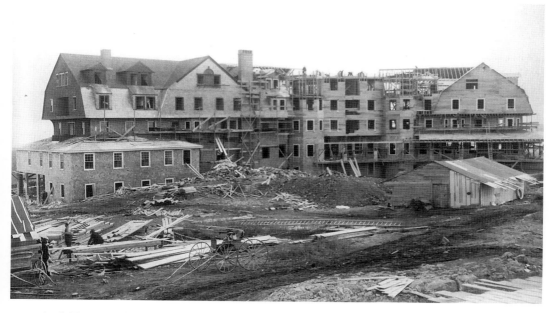

April 28, 1893. The builders were Edward and Samuel Blaisdell, York contractors who worked under the supervision of a New York architect.

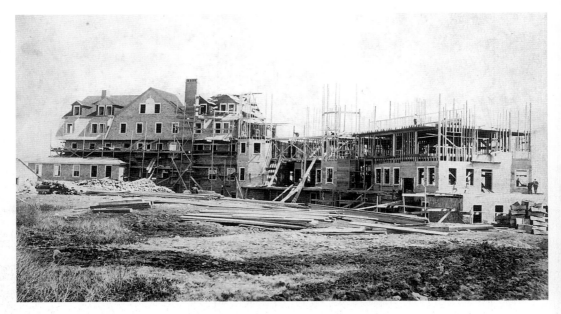

April 28, 1893. The contract specified that the building was to be completed in a mere ninety days.

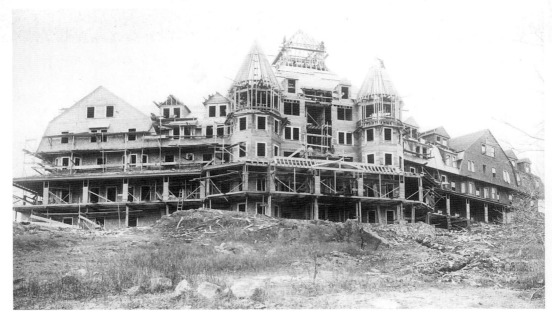

April 28, 1893. To meet the deadline, it was necessary to hire outside labor which led to a brief strike by local workers. Strikes were was virtually unknown in York and it was settled very quickly.

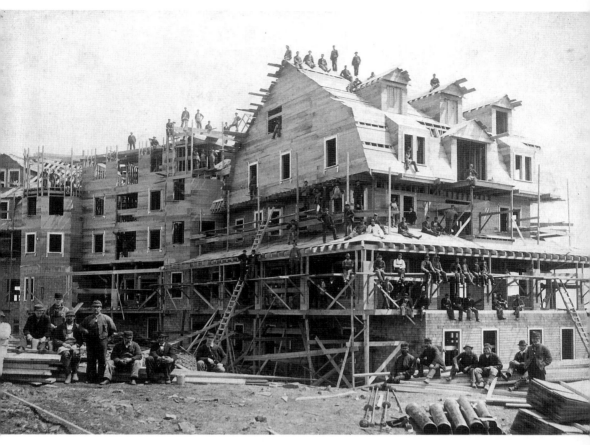

April 28, 1893. Week by week the structure grew, and the army of laborers worked long hours for modest pay.

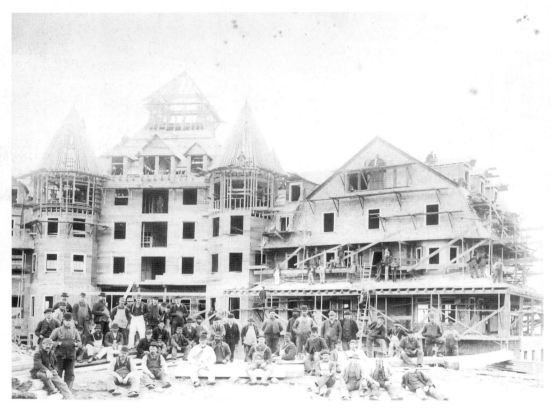

May 5, 1893. Only forty days after the first photograph was taken, the inn was in the final stages of construction. Apparently the only time the men stopped working was to pose for the photographer.

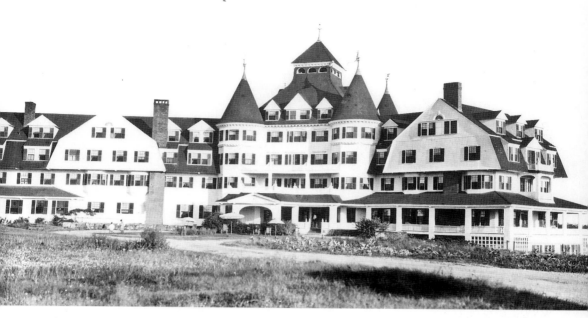

The Passaconaway Inn was managed by Col. Charles A. Wood from 1897 to 1937, when the building was torn down. The patrons were mostly southern and New York families, who enjoyed the refreshing sea breezes, golf, bowling, dancing and bathing on a private beach. It was a prestigious place for people of like interests to mingle during the summer months. Many patrons spent the entire summer at the hotel and it provided all the services that were expected by people of means.

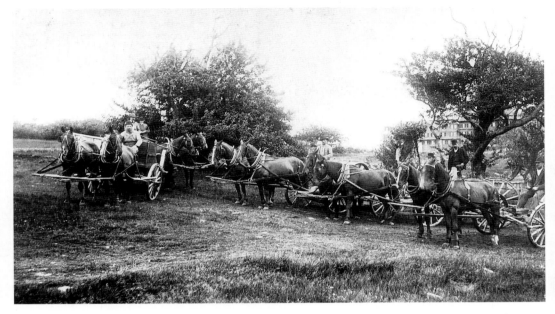

Local men found employment with their teams maintaining the grounds and doing the landscaping at the Passaconaway Inn. The men were paid by the day with extra compensation for the use of the teams. They planted, mowed, pulled up, dug, leveled, filled, and carted away.

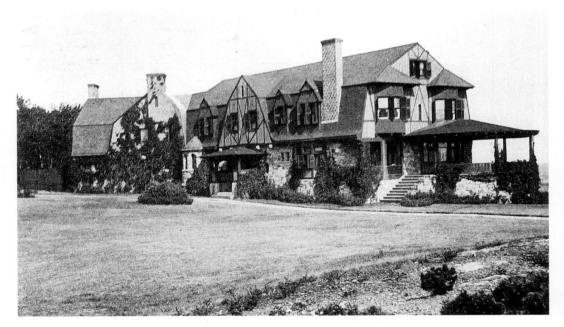

Greystone. One of the first three cottages built on York Cliffs was the home of J.N. Kinney. It was described as having "imposing proportions, quaint architecture, and a delightful location." The grounds were well-kept and there was an abundant supply of pure spring water pumped from a spring near Chase's Brook.

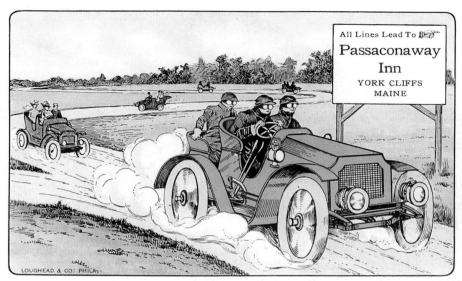

LEADING THE PROCESSION AT FORTY MILES AN HOUR

The influence of the automobile is reflected in these postcards advertising the Passaconaway Inn.

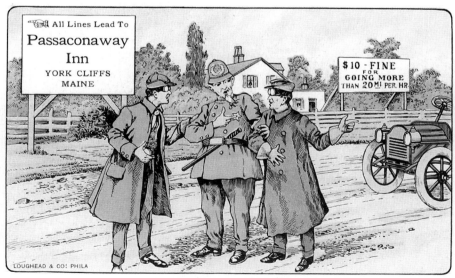

THIS HAINT NO SPEEDWAY

Traffic control was a problem for local law enforcement agencies who had to cope with wealthy "sports" in high–powered vehicles.

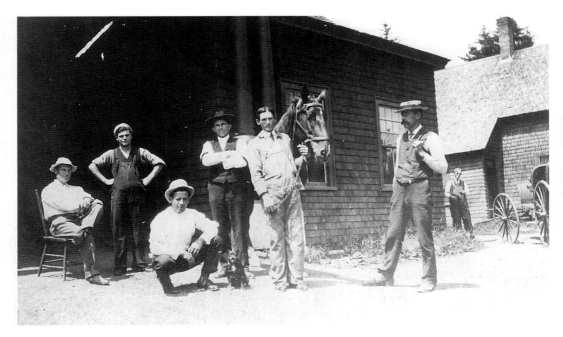

The public stables of the York Cliffs Improvement Society were large, airy, and the equipment was inferior to none. The stable was destroyed in a forest fire on 14 July 1912.

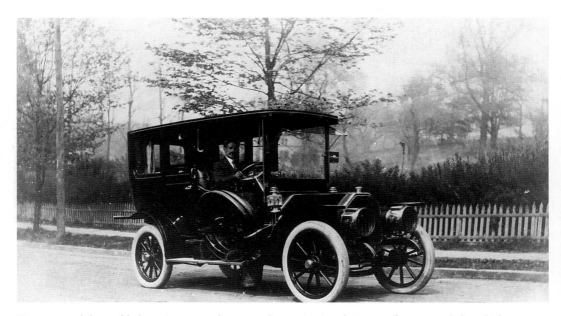

New automobiles enabled tourists to travel to more distant sites in relative comfort. Expanded roadside services encouraged enthusiastic sightseers to take longer and longer trips.

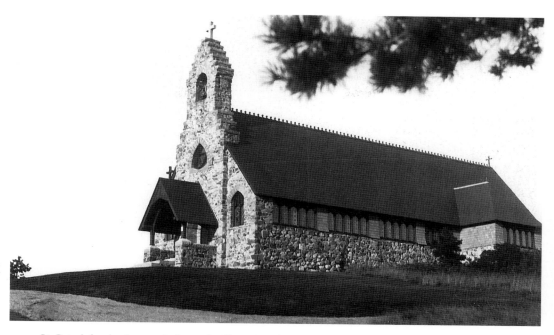

St. Peter's by the Sea was built on the Shore Road to Ogunquit in 1898. It stood on the crest of a hill near the entrance to Bald Head Cliff, an impressive setting for a dignified structure.

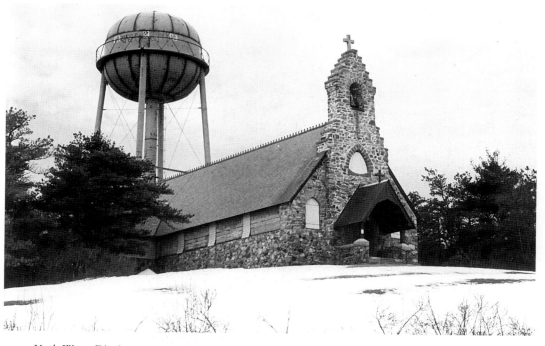

York Water District trustees were attracted by the high elevation as a site for a water tower. In 1966, they erected a giant structure that dwarfed the church building and created a storm of controversy. This is how it appeared in 1967 before the tower was removed.

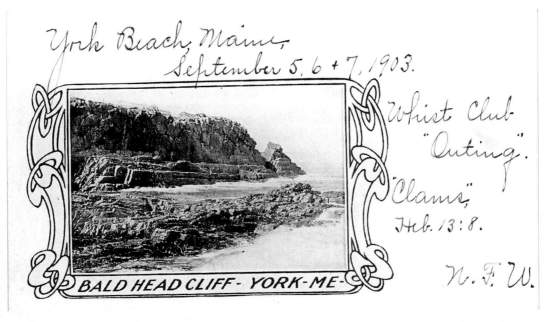

York Beach, Maine,
September 5, 6 + 7, 1903.

Whist Club
"Outing".

"Clams",
Feb. 13 : 8.

N. F. W.

BALD HEAD CLIFF - YORK-ME-

This postcatd of Bald Head Cliff has a variety of messages that had to be written on the front of the card because there was no provision for messages on the back.

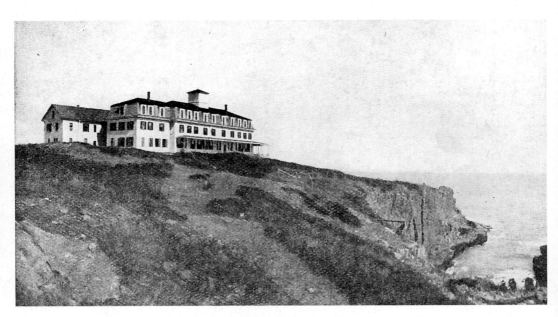

The original Cliff House overlooking Bald Head Cliff is shown on this early postcard.

six

What do we do in the winter?

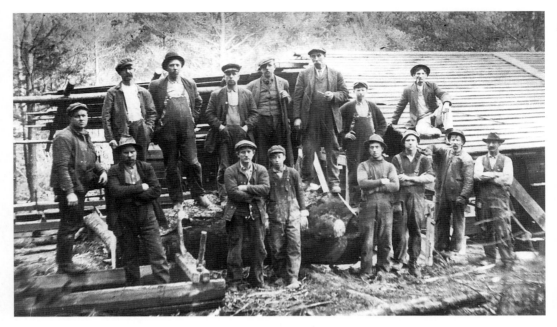

The crew of the Young Hobson sawmill near Boulter Dam. Rear, left to right: Norris Trafton, Charles Arnold, George Albert Moulton, Will Woodward, Frank Goodwin, Frank Drew, -?-, Leon Hasty. Front, left to right: Burt Currier, Burt Kimball, Herman Starkey, Malcolm Cheney, Johnny Gray, -?-, and Nakim Littlefield.

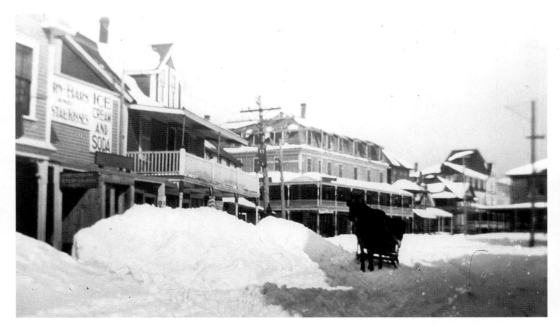

Downtown York Beach under a blanket of snow. There was little effort made to remove the snow and sleighs were used for transportation.

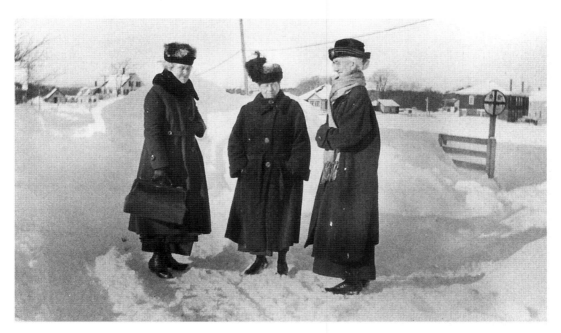

Snow did not prevent local residents from socializing. Mrs. Gough, Mrs. Annie Emery and a friend are modeling what a well-dressed York Beach lady wears in the winter. The three ladies are standing on Church Street in front of the Union Congregational Church.

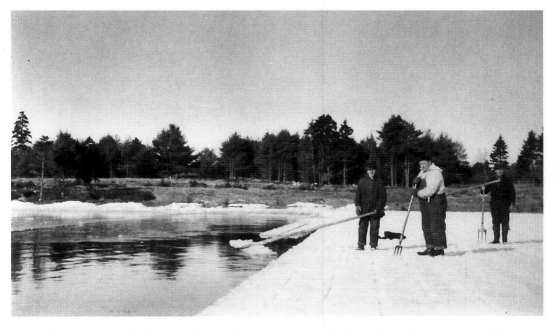

The Norton Ice Pond. Ice cutting was a local trade that provided brief periods of employment for area residents. They cut and stored the ice that would cool cottage ice boxes during the warm summer months.

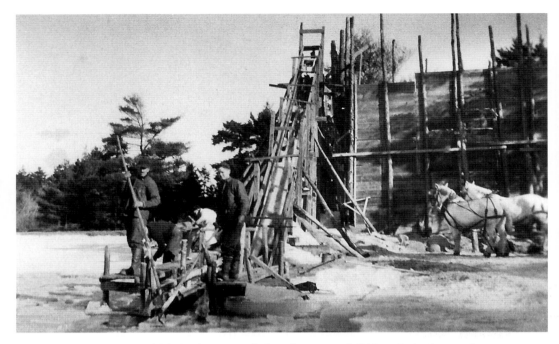

The Norton Ice House. Each block of ice was pulled up the ramp and slid into the ice house where workers pushed it into place and covered it with sawdust. The sawdust kept the blocks from freezing together and provided some degree of insulation. The horses were used to clear the snow from the pond, score the ice to guide the sawyers, and pull the ice up the ramp.

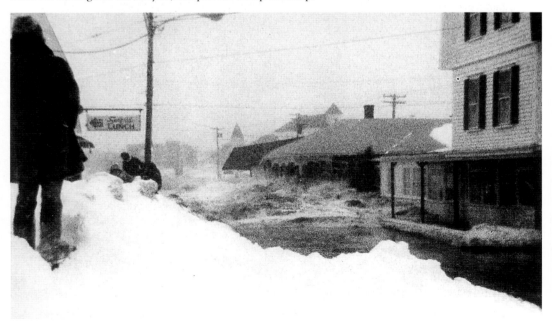

Violent storms periodically flooded the streets of York Beach and filled them with sand. This storm in 1978 destroyed the Chamber of Commerce building.

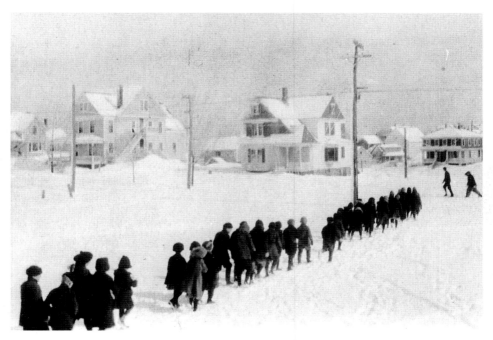

York Beach school children marching to school during the winter of 1920-21.

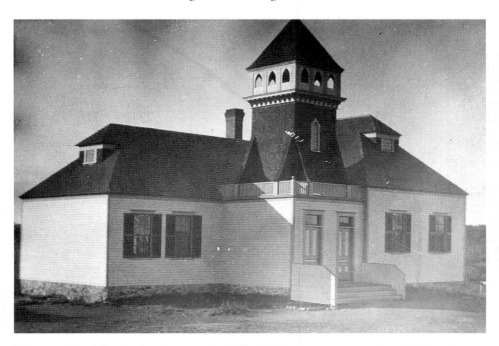

The second York Beach school was used until 1911. This was a two room school with grades one through four on the left, and five through eight on the right. An addition was added before 1910 at the rear of the building. It housed a stairway to the basement where toilets were installed. Before this time, students used outside facilities located at the edge of the lot on the left.

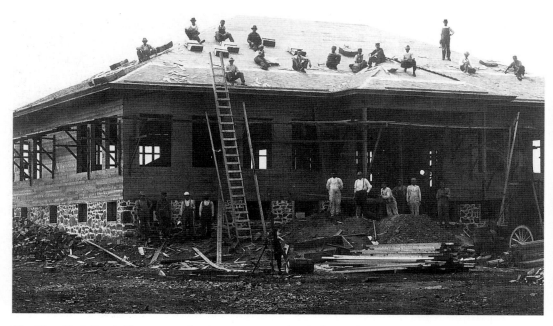

The New York Beach Elementary school was constructed with the usual army of workmen.

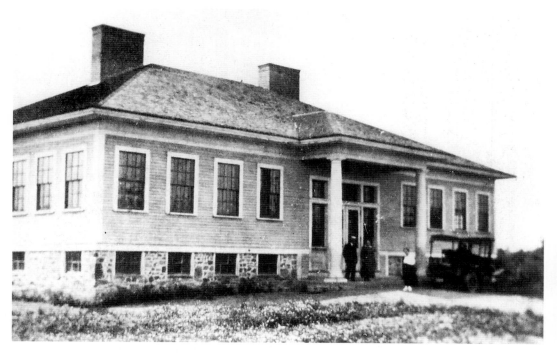

The third York Beach school as it appeared in 1920.

The Cape Neddick Baptist Church decorated for a Christmas party. The First Baptist Society of Cape Neddick was formed on 20 August 1829, with a membership of five men and seven women. They took over the Methodist church when the Methodist Society was dissolved. Some of its members joined with the Baptists to form the First Baptist Church of Cape Neddick.

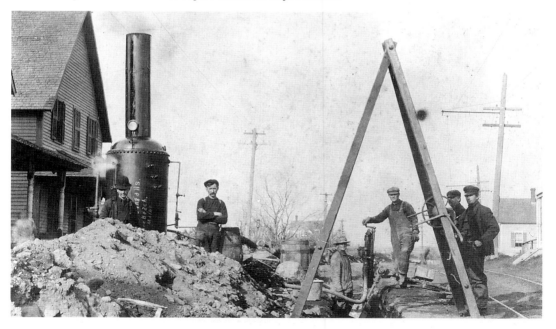

Digging trenches for water pipes on top of Hildreth's Hill in York Beach. Note the steam-driven drill and the trolley car tracks. The York Shore Water Company was organized in 1895 to supply the towns of York and Wells with pure water and to protect the waters of Chase's Pond.

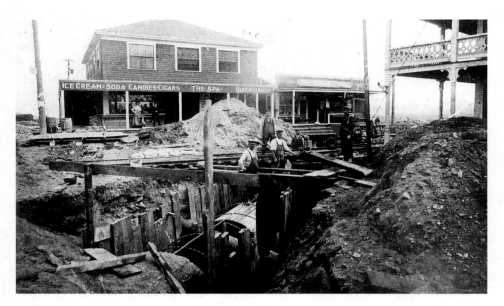

Construction of the Penstock to contain the water from a small brook that drained a swamp behind the business district. The downtown area flooded when heavy rainfalls exceeded the drainage capacity of the penstock, the tube became blocked, or high tides inundated the area.

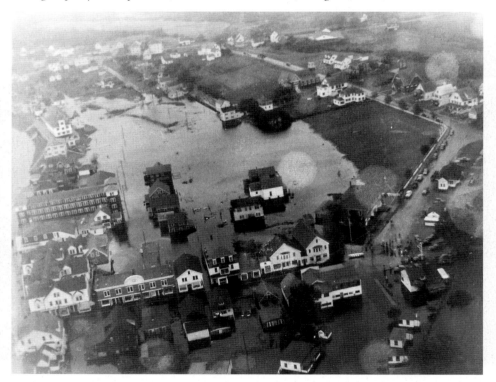

Floods were common because most of the York Beach business district was built on a marsh which became a large pond after a heavy rainfall.

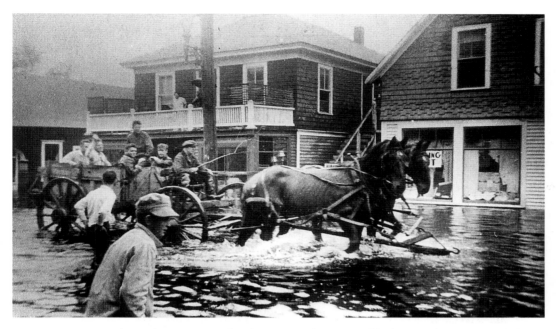

Roger Norton driving his team up Railroad Avenue in the center of the business district. Marooned residents are watching from a second-story porch and the wagon is filled with young people who were enjoying the adventure of this flood.

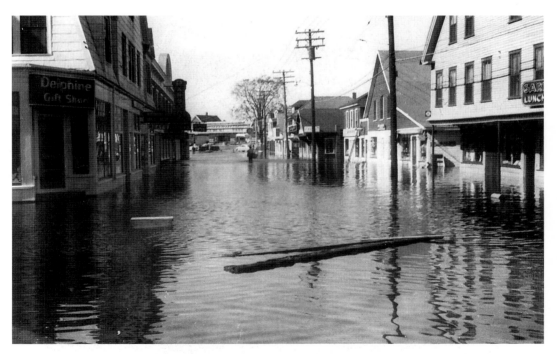

There have been many floods over the years. This view is toward Funland Park with debris floating in the foreground.

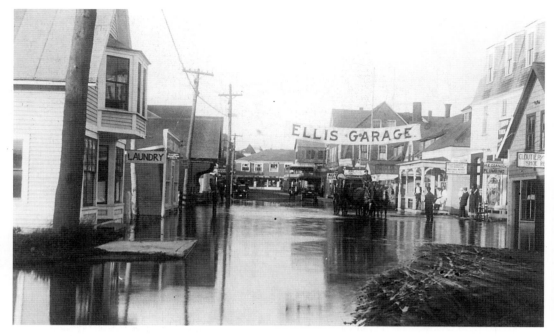

Another earlier flood. The view is looking toward the Goldenrod Restaurant and a stagecoach can be seen moving up the street.

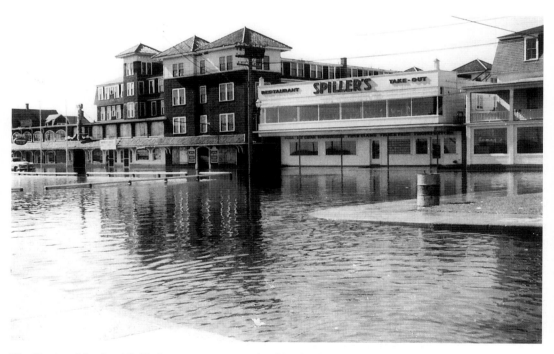

The Breakers Hotel and Spiller's restaurant were isolated by the flood waters which reached every part of the business district.

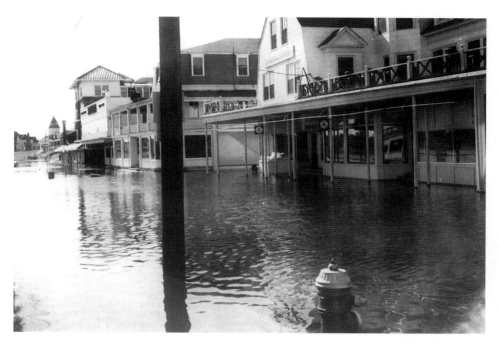

Cobb's Algonquin and the Kearsarge Hotel were also flooded.

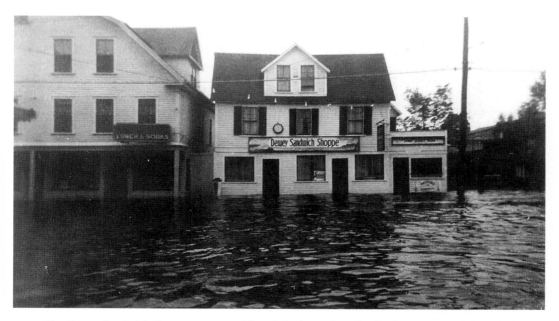

The Dewey Sandwich Shoppe was accessible only by boat when the flood waters surged through the square.

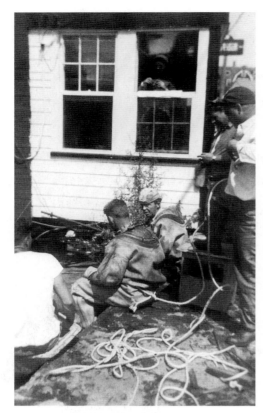

Left: Two hard hat divers preparing to go into the penstock and remove debris which contributed to the flood conditions.

Below: The concrete shore walk was washed away by the heavy surf and the brook re-established itself after a major storm.

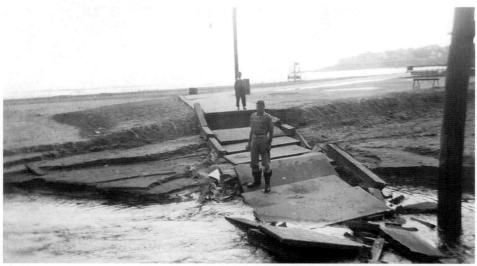

Opposite: The schooner *Robert W.* went ashore on Long Sands Beach on 12 February 1923. This photograph, taken in the spring of 1923, confirms that the masts and rigging were still in place and the hulk was a new attraction for beach-goers. Left to right: Junior Trusedale, William Marden Jr., and William Marden Sr.

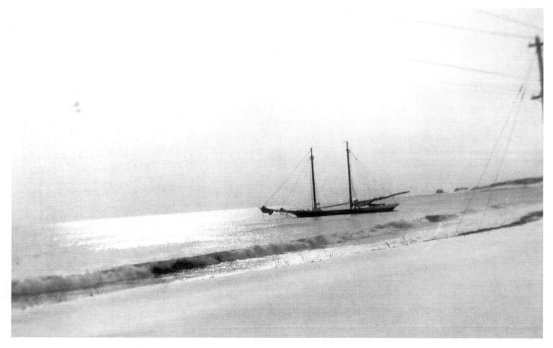

The schooner came ashore on Long Sands Beach in a blinding snowstorm. The two-man crew was lashed to the rigging for nearly twelve hours before rescuers could reach them at 10.15 in the evening.

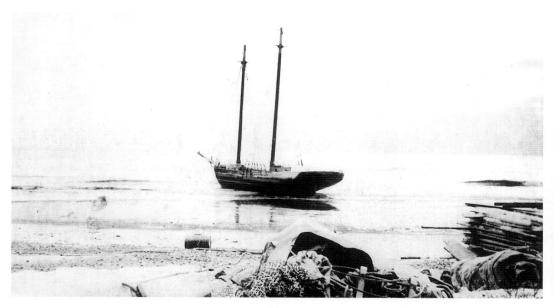

Ernest Hobson took charge of the cargo which was piled on the shore. Cato Philbrick apparently purchased the main mast to use as a flag pole at the York Harbor Reading Room. Everything of value was removed and the hulk left to rot on the beach.

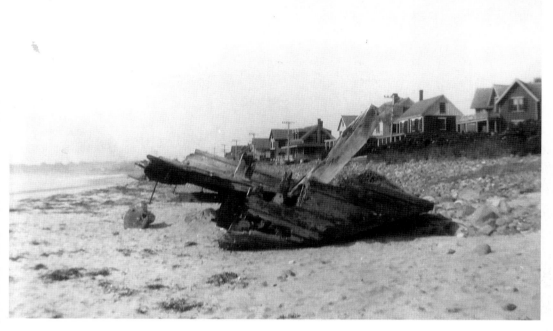

The eighty-two-foot schooner gradually settled into the sand and broke up. The rotting hulk was set on fire several times during Fourth of July celebrations.

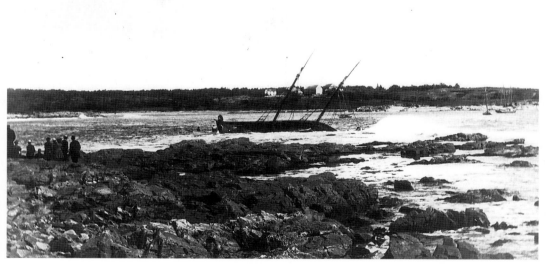

The *Hattie J. Averhill* was wrecked on the rocks at the mouth of Cape Neddick Harbor opposite the Bay Haven Yacht Club.

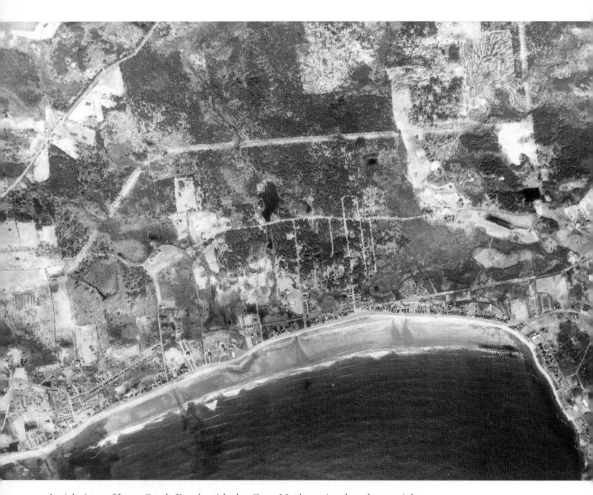

Aerial view of Long Sands Beach with the Cape Neck peninsula at lower right.

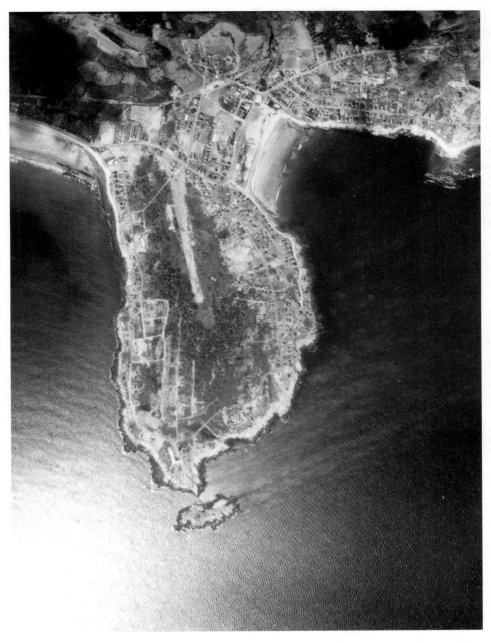

Cape Neck and the Nubble. The airstrip in the center of the peninsula was once an airport and is now Airport Drive, a development. The York Beach Aviation Company was operated by Bob and Gerry Turner from 1946 to 1952 on land leased from Nellie Bowden.

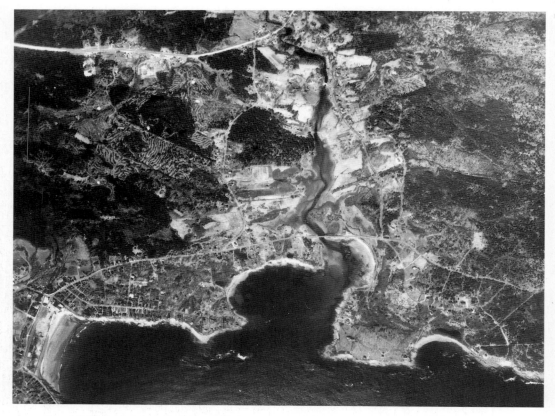

Cape Neddick Harbor with Short Sands Beach at lower left. In the early days, Cape Neddick
Harbor was entered through a drawbridge which enabled large sailing vessels to enter with cargo
and passengers. The new bridge apparently changed the flow of the river causing large sand
deposits to fill the harbor.

Acknowledgments

Helen Grover; The Seavey Collection; Norman Chase; Frank Parsons; David Hilton; Ruth
Freeman; Robert Lee; Marian Woodward; Russell Freeman; Joseph Hoyt; Marguerite
Macdonough; Wesley Austin; The Wagner Collection; Richard Brooks; Joseph Bobroff; Peter
Moore; William Marden; Joseph Ramelli; Harry Bracy; Woodrow Bowden; Howard Moulton;
The Portsmouth Athenaeum; Betty Bridges; Robert T. Donnell; Harry Hutchins; The Goldenrod;
Mrs. Charles Main; Jed Gilchrist; J.R. Cummings; Deborah Young; Helen Vincent; Norm
Brunelle; John Hutchinson; Romena Johnson; Geraldine Bardwell; Elsa Adams; High Dunston;
David Brinkman; Louise Sodano; June Perry; Cynthia Dutton; David Mullin; Mary Dukeshire;
Bill Rogan; Roger Currier; Robert Mograth; Midge Flanders.